# Double Life

# Double Life

Wu Tsang

Haegue Yang

Essays by
Dean Daderko and Litia Perta

Jérôme Bel

# Contents

10      Director's Foreword

13      Curator's Acknowledgments

16      Plates

44      *A Spectacle And Nothing Strange*
        Dean Daderko

76      *Your Heart is a Strong Muscle, It Squeezes Very Good*
        Litia Perta

111     Plates

163     Works in the Exhibition

164     Biographies

172     Credits and Colophon

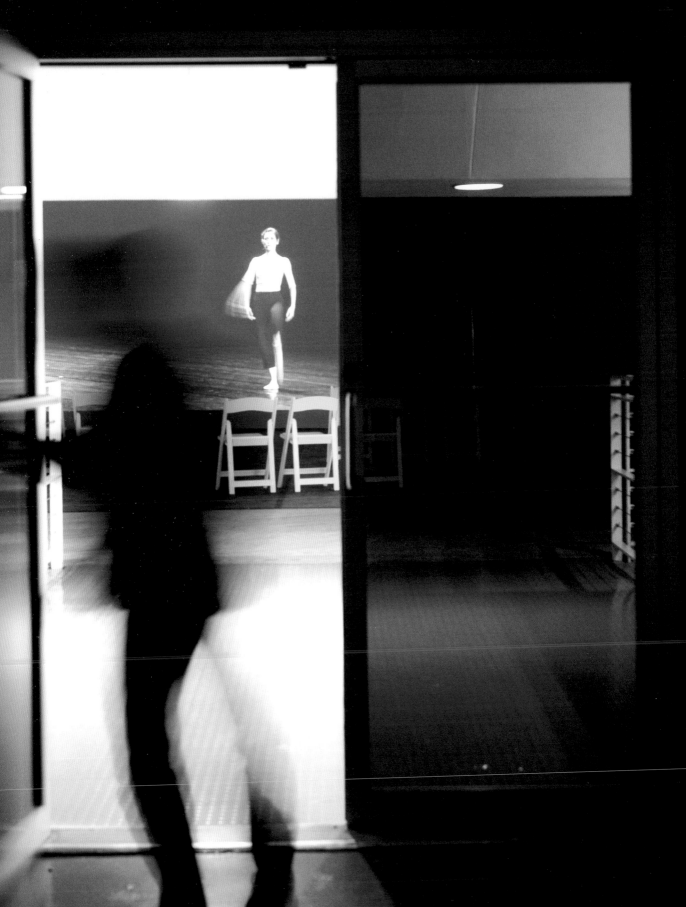

# Director's

# Foreword

It is my great pleasure to introduce the work of three of today's most widely celebrated artists, hailing from different parts of the world and working in wildly different artistic arenas, while maintaining a relationship to the art-historical category of performance. I guarantee that visitors to *Double Life*—featuring recent works by Haegue Yang, Jérôme Bel, and Wu Tsang— will have an incredible experience that they will remember for a long time. I know this because these time-based artists have taken me on emotional and intellectual journeys in the past.

I am a tremendously lucky art viewer in that I get to attend international exhibitions on a regular basis. I have been fortunate to see each of these tremendous art-makers arrive at breakthrough moments, and am eternally grateful for their insights into life and culture. In the cases of Haegue Yang and Jérôme Bel, the most memorable works I have seen were presented in Europe, and for Wu Tsang, those were in New York and also at Diverse Works here in Houston. Together, the power of these works—all on the cutting edge of cultural production—multiplies exponentially.

I am grateful to our visionary curator, Dean Daderko, for putting these three artists in dialogue. The fact that these art-makers all present or re-present aspects of "real life" as theatrical performances was lost on me until he proposed this group for a potential show. Through his curatorial insight, the work of three great artists has been united to make a whole greater than its parts, and it thrills me.

CAMH's primary function—offering our audiences the experience of seeing significant works installed in their originally-conceived forms, rather than in limited versions on the Internet or described in magazines—is highlighted in Double Life. All three of these works require ample time and space to be understood. I know that the experience of seeing these artworks in a skillfully deployed constellation in CAMH's unique space will offer our uniquely passionate audience the chance to savor each artist's contribution, and to think about art production today in a deeper and more profound way.

CAMH's dedicated staff has contributed to making this exhibition happen and deserves praise here. In particular, I would like to single out a few key players who helped us overcome challenges: Controller Monica Hoffman and Deputy Director Amber Winsor made arrangements across international borders work. They were joined by Assistant to the Director Shane Platt and Curatorial Business Manager Patricia Restrepo on the 101 logistical issues that ambitious international exhibitions like Double Life present. Director of Community Engagement Connie McAllister and Education and Programs Manager Daniel Atkinson have done a bang-up job of making sure our live events are flawless and memorable. And last but certainly not least, Registrar Tim Barkley and Head Preparator Jeff Shore managed to make non-traditional media works function perfectly as enveloping experiences.

CAMH's trustees are unflagging in their support of our shows, and three who have been especially passionate about Double Life need special mention here. Thanks to Andrew Schirmeister, with whom I was lucky enough to experience one of Jérôme Bel's performances at dOCUMENTA (13), and to Dillon Kyle and Glen Gonzalez, whose efforts and generous support encourage CAMH's staff to always set high goals for ourselves, and to bring great art to Houston. I have been told more than once that my job as director is to "keep CAMH wild," and Double Life does just that!

—Bill Arning

# Curator's

# Acknowledgments

*Double Life* has given me an opportunity to work with three internationally recognized artists of the highest caliber, and I thoroughly enjoyed my exchanges with Jérôme Bel, Wu Tsang, and Haegue Yang as this exhibition came together. I thank each of them for their time, thought, and efforts.

The generous support of the Cullen Trust for the Performing Arts has made Jérôme Bel's participation in *Double Life* possible and ensured that the Contemporary Arts Museum Houston's audiences could enjoy performances of *Cédric Andrieux* at no cost. Bel's project also received support from the French-U.S. Exchange in Dance (FUSED), a program of the New England Foundation for the Arts' National Dance Project, the Cultural Services of the French Embassy in the United States, and FACE (French American Cultural Exchange), with lead funding from the Doris Duke Charitable Foundation, The Andrew W. Mellon Foundation, and additional funding from the Florence Gould Foundation. Technical facilitation of *Cédric Andrieux* was ably implemented by Miguel Medina and his team from Aura Systems, Inc.

The Brown Foundation's boundless generosity underwrites the publication of catalogues documenting every exhibition CAMH organizes. The circulation of these catalogues allows our exhibitions in Houston to reach local and international audiences who may not

have the opportunity to step through the museum's doors.

CAMH's trustees are this museum's bedrock: they offer unparalleled guidance, resources, and vision. I applaud them for being our most passionate ambassadors in our local community and at large. In particular, I would like to recognize both Dillon Kyle and Sam Lasseter and Andrew and Robin Schirrmeister for their sustaining enthusiasm, the warm hospitality they showed our visitors, and their inspiring generosity.

CAMH is fortunate to have ardent supporters like Glen Gonzalez and Steve Summers on our side; they graciously opened their home to host a dinner celebrate the inauguration of *Double Life* and I thank them enthusiastically for their generosity. Thanks also to Mark McCray who joined Bill Arning in welcoming one of our visiting artists with open arms.

This exhibition could not have been realized without the kind collaboration of many individuals who supported each of the participating artists:

Cédric Andrieux agreed early on to travel to Houston to reprise the solo Jérôme Bel created for him, and I cannot thank him enough for his commitment. The presentation of *Veronique*

*Doisneau* was dependent on the efforts of Olivier Aldéano and Emma Enjalbert from the Department of Dance at the Opéra National de Paris, and the attention of Alexandra Faux Aubes, Emilie Huc, Denis Morlière, and Annick Waterkeyn at Telemondis, France. I offer my heartfelt thanks to Sandro Grando and Rebecca Lee in Jérôme Bel's office for their sustained support throughout this project. Thanks are also due to Sylvie Christophe, Cultural Attaché, and Mary Einbinder, Cultural Service Coordinator at the French Consulate, in Houston for their enthusiastic support of CAMH exhibitions.

CAMH's commission of a multimedia artwork by Wu Tsang with Fred Moten would not have happened without Moten's most gracious collaboration, and I thank him for his investment in this project. I extend my gratitude to Michael Clifton and Silke Lindner of Clifton Benevento in New York, and Michael Benevento whose eponymously named gallery in Los Angeles both dependably supported the presentation of Tsang's work. Producer Melissa Haizlip ably organized the myriad details of Tsang's commissioned project for this exhibition. Charles Aubin and Esa Nickles of Performa generously offered that organization's assistance by providing documentation of a performance by Tsang. Cliff

Anderson of Independent Theatre Supply Co. in San Antonio and Tish Stringer of Rice University amiably facilitated Wu Tsang's film installation, and I appreciate their expert assistance.

The team members in Haegue Yang's Berlin and Seoul studios—Ah-Yun Chae, Jiyoung Kim, Sylbee Kim, Jeonghwa Min, Katharina Schwerendt, and Heejung Yeh—coordinated the details surrounding the presentation of *Mountains of Encounter* with efficiency and great care, and I gratefully acknowledge their efforts. I am indebted to Arne Clemens at Interzone GmbH for his technical fabrication expertise and his professionalism. I extend my most sincere thanks to Petra Graf, Barbara Wien, and Wilma Lukatsch at Wien Lukatsch in Berlin and Kristina Karahalios, Tara Ramadan, and Jeffrey Rowledge at Greene Naftali in New York for their kind assistance, timeliness, interest, and generous support. Kevin Friddell of Bright Star Productions, Inc., kindly offered his professional expertise to program a complex lighting sequence for Yang. Thanks are also due to John Murphy, Cindy Brightenberg and Heather Baird in the L. Tom Perry Special Collections Library at Brigham Young University for supplying the images of Helen Foster Snow and Jang Jirak that appear in this publication.

A special thanks to Litia Perta, Assistant Professor in the Critical and Curatorial Studies Program at the Claire Trevor School of the Arts at the University of California, Irvine, for bringing sustaining theory and a poetic voice to her insightful essay in this catalogue. It has, once again, been a pleasure to work with Peter and Joanna Ahlberg of AHL&CO to design the book that you are now holding; their creative approach gives the exhibition another life in print. Paul Hester brought a sense of clarity and precision to documenting *Double Life*'s breadth and depth, and I always appreciate the chance to work with him. Thanks to Eric Quinn and his crew at Building Unlimited for their construction of our exhibition architecture, and to Jabbar Roberts and Great Signs for their precision and care in the production and installation of the exhibition's way-finding graphics.

The support and collaboration of my colleagues at CAMH is invaluable. The advice and generous mentorship I receive from Director Bill Arning and Senior Curator Valerie Cassel Oliver strengthens my practice. The hard work of former Curatorial Associate Nancy O'Connor laid the groundwork for this exhibition, and I will always value her precision and sage advice. I am pleased that former Curatorial Intern Patricia Restrepo is now our department's Curatorial Business Manager; she has already proved herself an invaluable collaborator. Thanks as well to Curatorial Intern Haydyn Jackson for her dutiful assistance. CAMH Deputy Director Amber Winsor's laudable efforts ensure CAMH's stable fiscal future. Current and former colleagues who assist her in these efforts include: Amanda Bredbenner, Libby Conine, Emily Crowe, Chinelo Ikejimba, and Beth Peré. Connie McAllister and Max Fields can be counted on to energize CAMH's growing public, whether online or in-person. Daniel Atkinson extends the reach of our exhibitions with thoughtful programming, and Oscar Cornejo and Jamal Cyrus educate and enthuse new generations of visitors. Quincy Berry warmly welcomes our visitors. Amanda Thomas and Ronald Jones help keep our communications fresh. Tim Barkley, Kenya Evans, Mike Reed, and Jeff Shore attend to the details of CAMH's physical plant and our installations with the utmost care. Their assistants for this exhibition were Jessie Anderson, Jonathon Barksdale, Jonathan Leach, Paul Middendorf, and Bret Shirley. Monica Hoffmann keeps us on point fiscally, Shane Platt ensures we all have a clear view of the big picture, and Sue Pruden supplies us everything we never knew we needed in CAMH's Museum Shop.

My heartfelt thanks are also due to the following individuals, and others I have not mentioned, whose input, assistance, and energy truly enriched this exhibition: Rachel Berkman, Rachel Berks, Dan Byers, Rachel Cook, Thomas Devaney, Katherine Hubbard, Alhena Katsof, Fabienne Lasserre, Frances Lazare, Élisabeth Lebovici, MPA, Ulrike Müller, Matthew Rowe, Amy Sadao, A. L. Steiner, Anna Stothart, Lanka Tattersall, and Michelle White.

—Dean Daderko

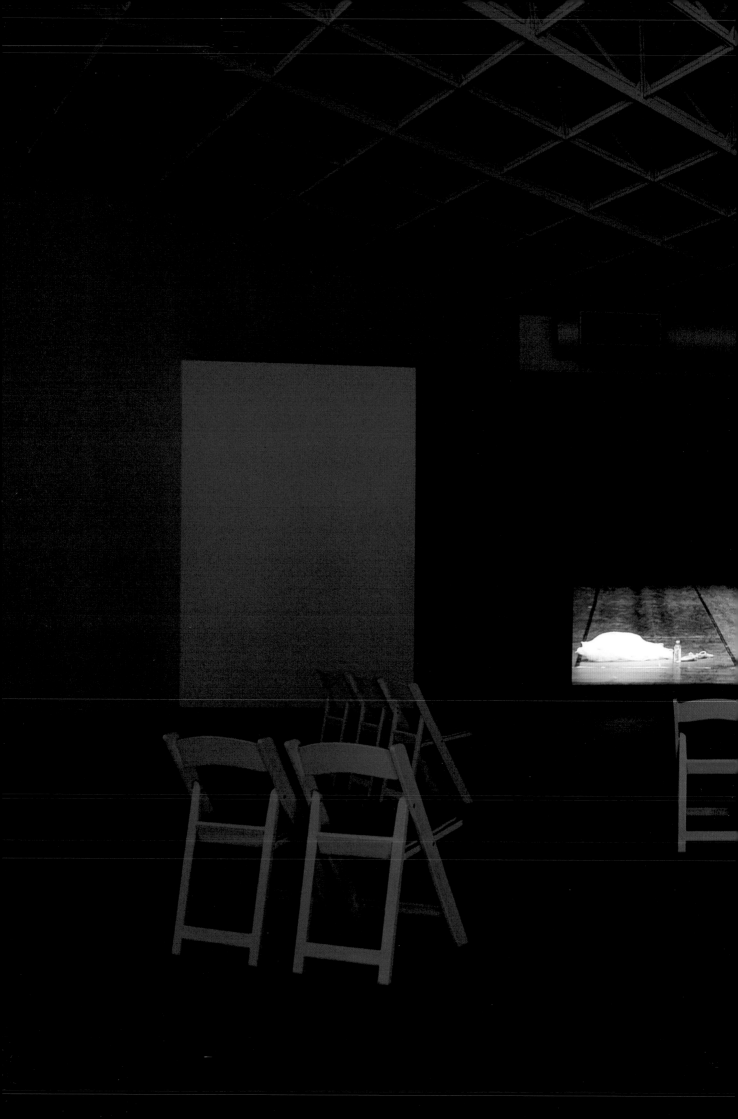

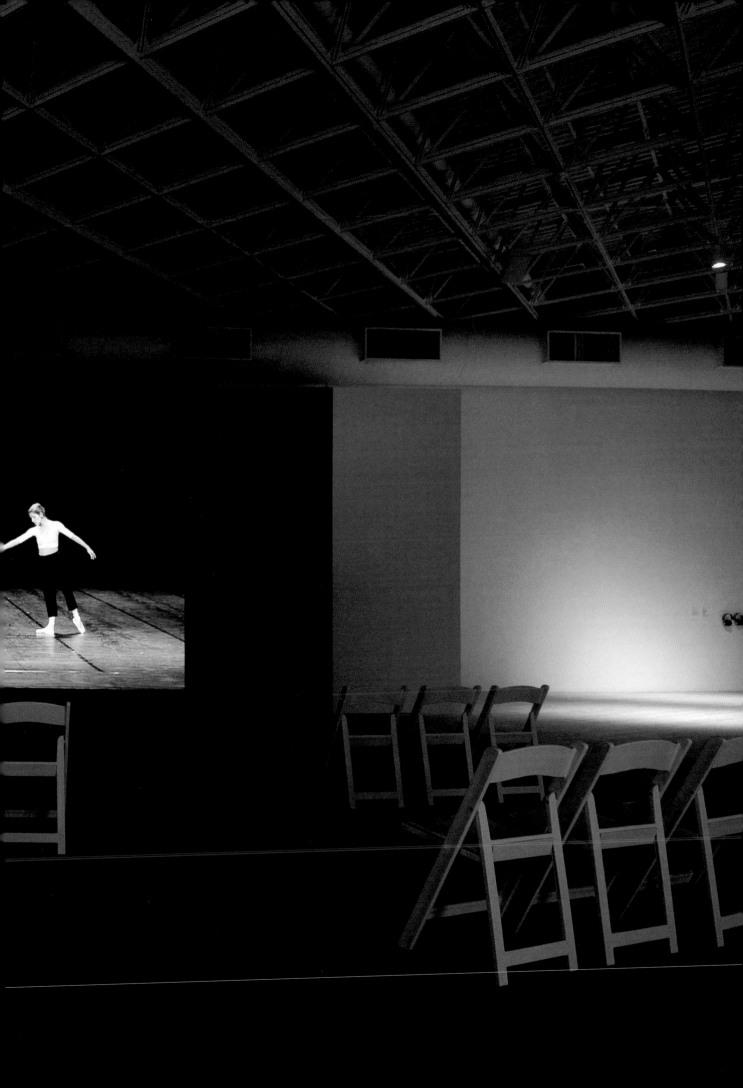

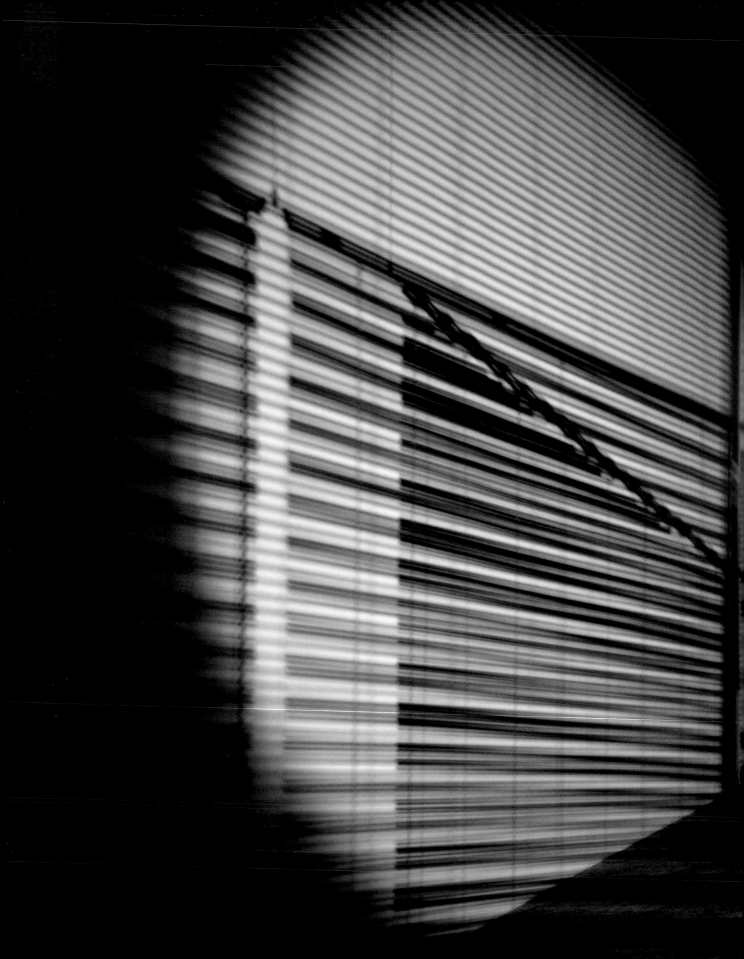

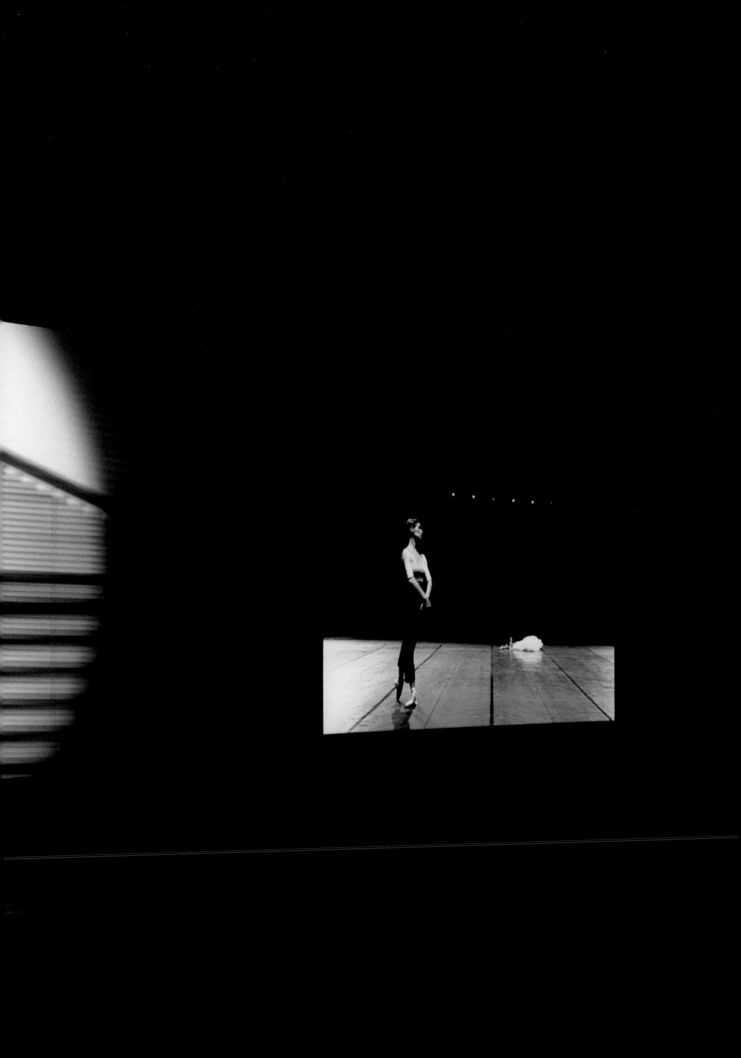

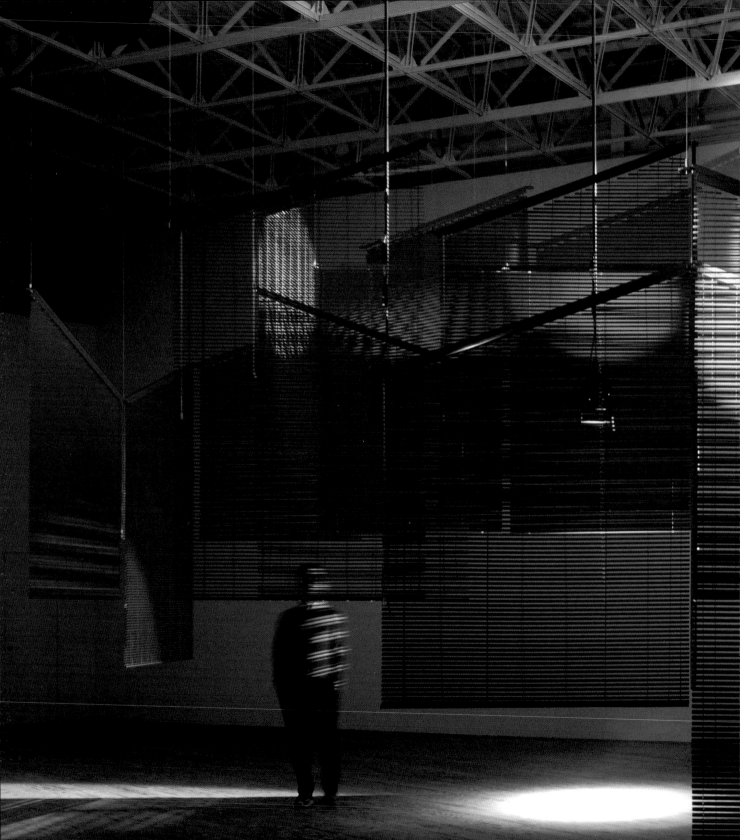

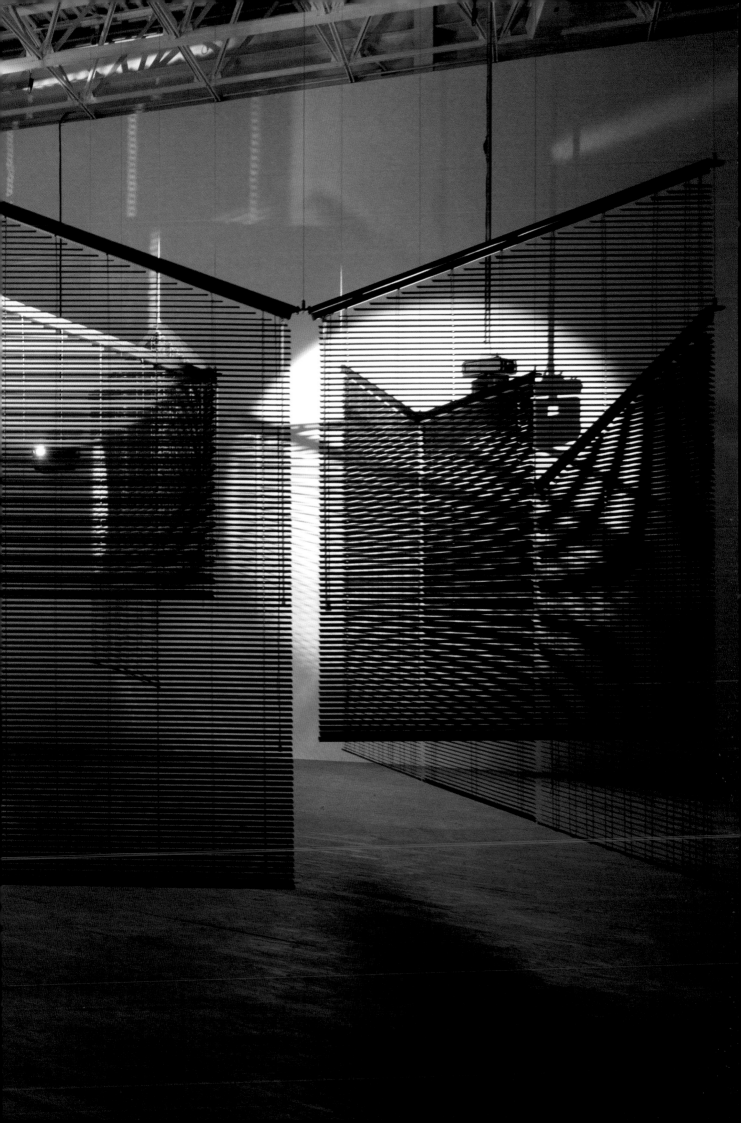

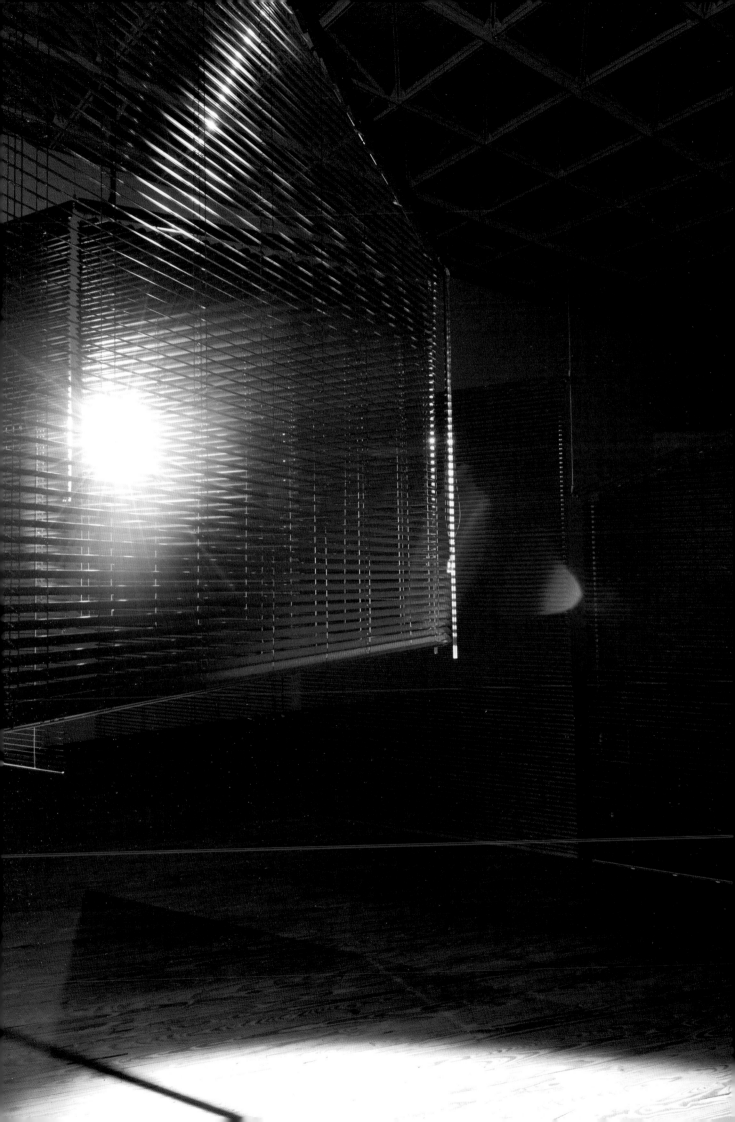

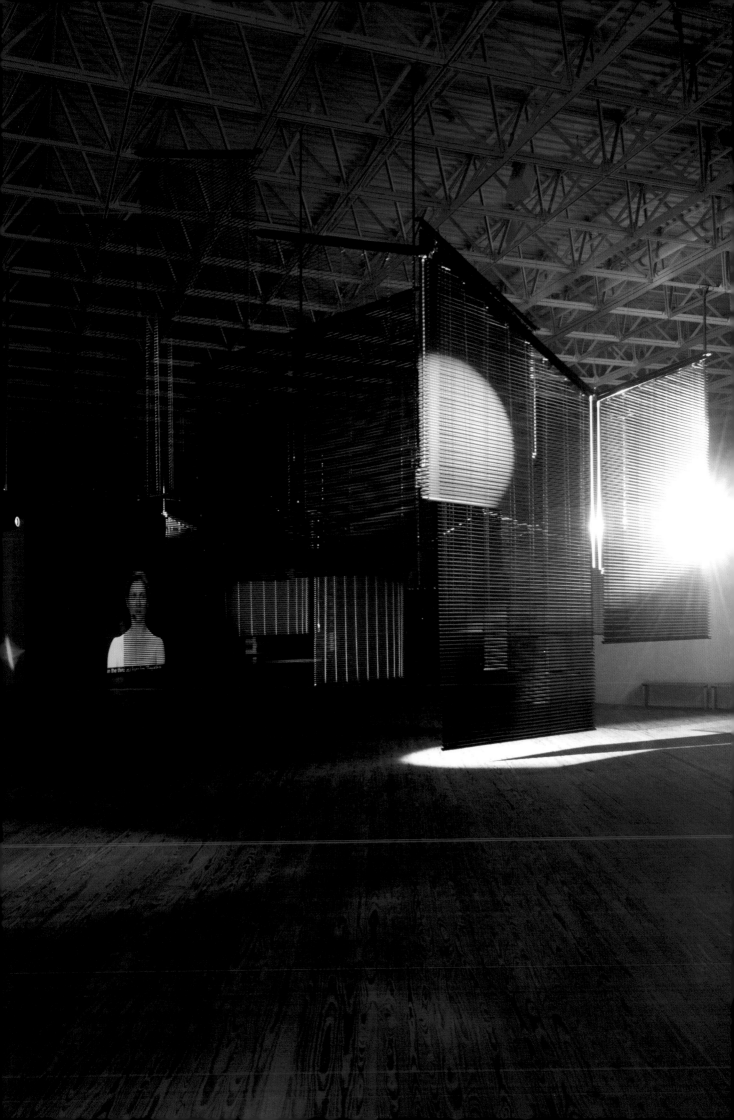

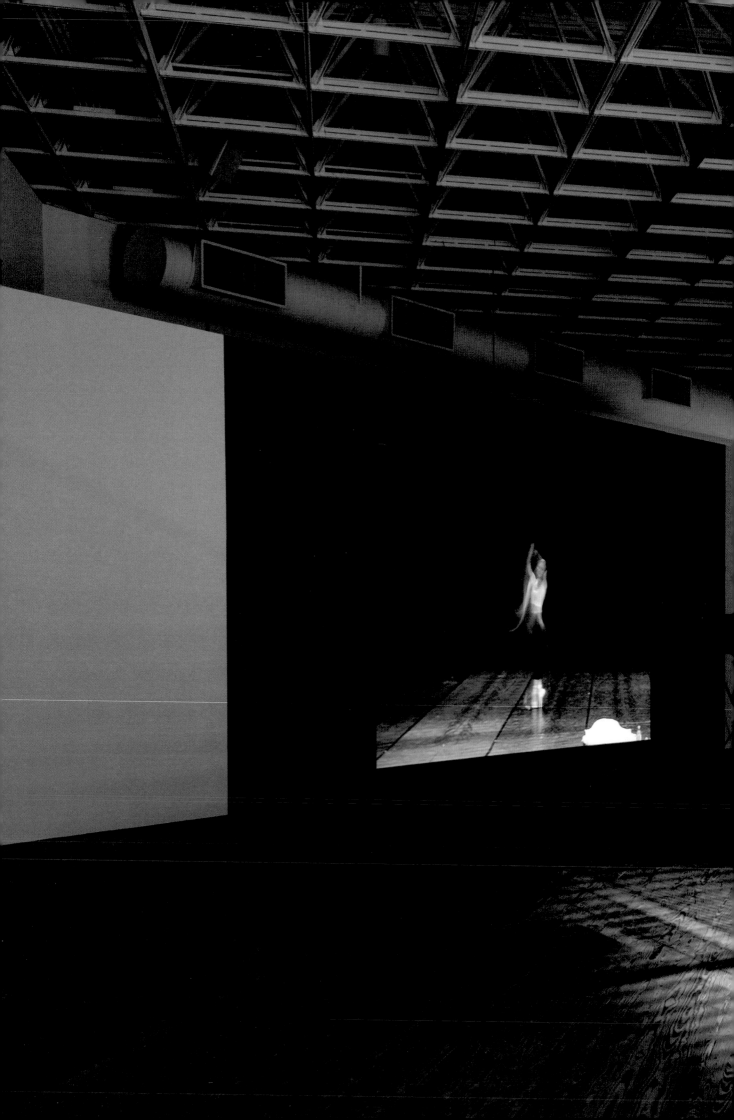

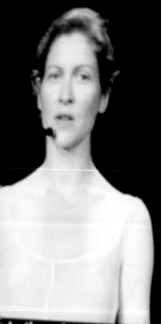

to the other dancers'rythm

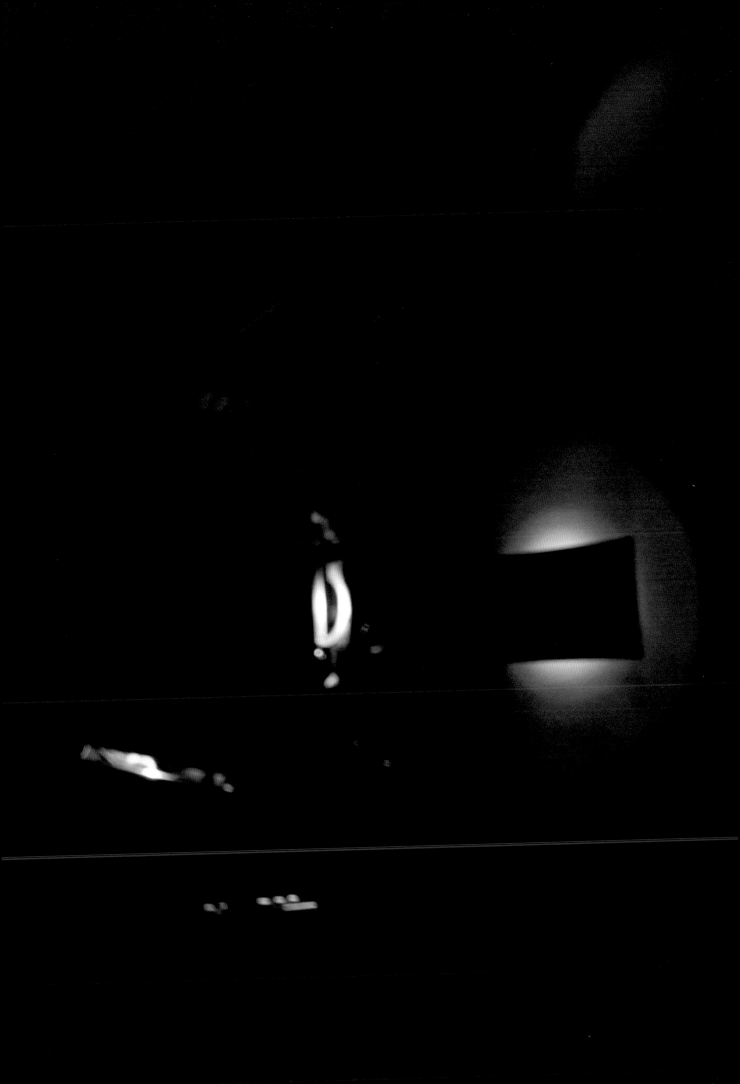

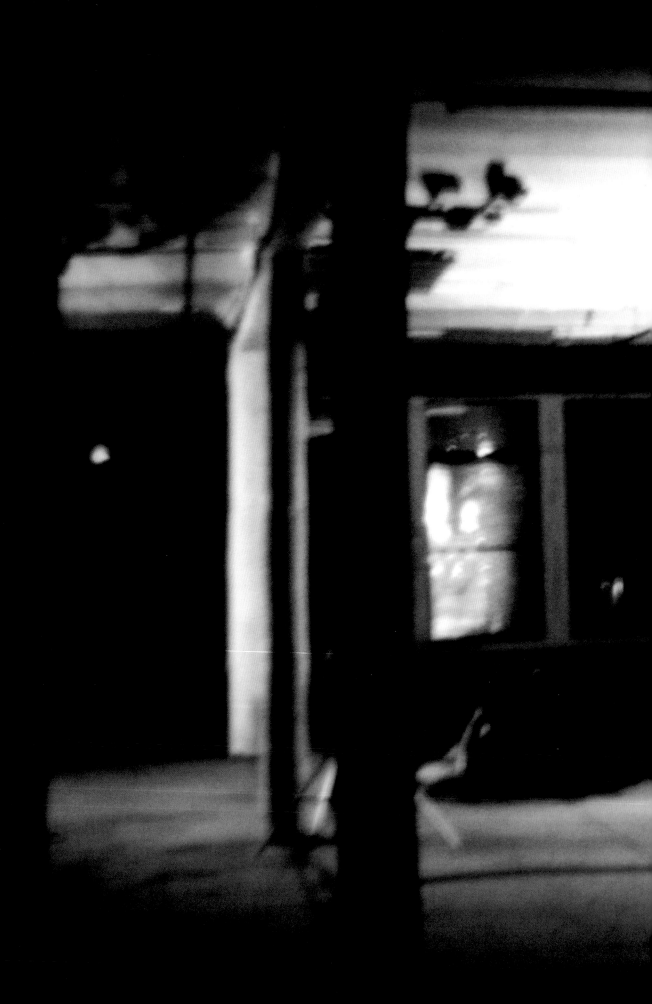

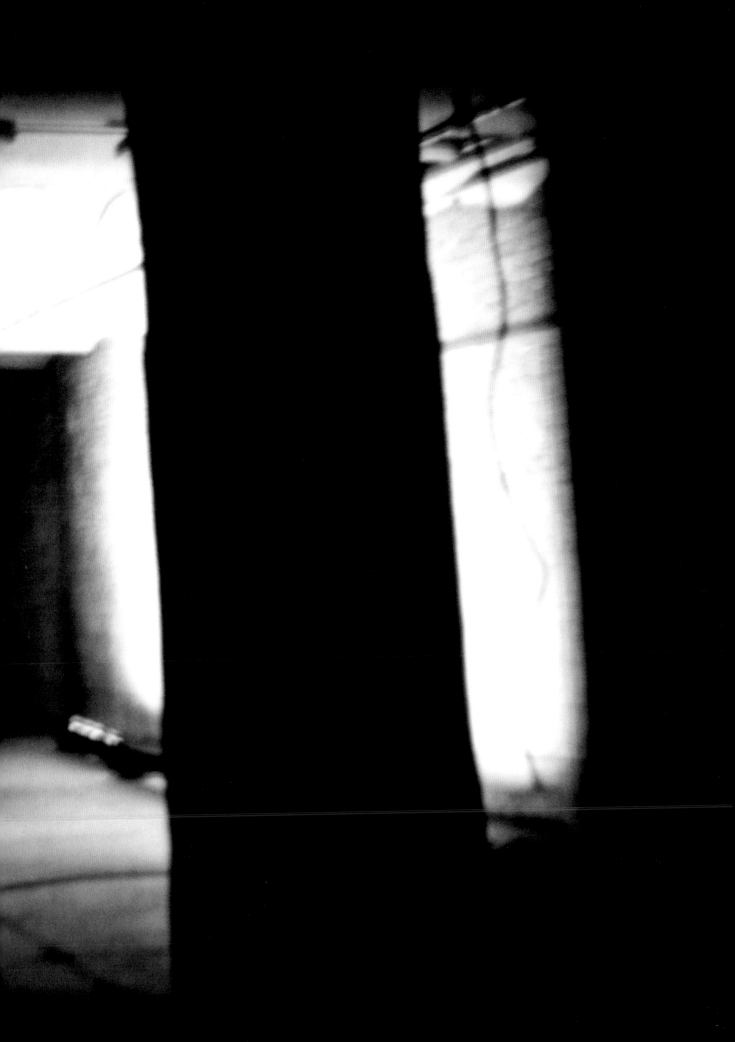

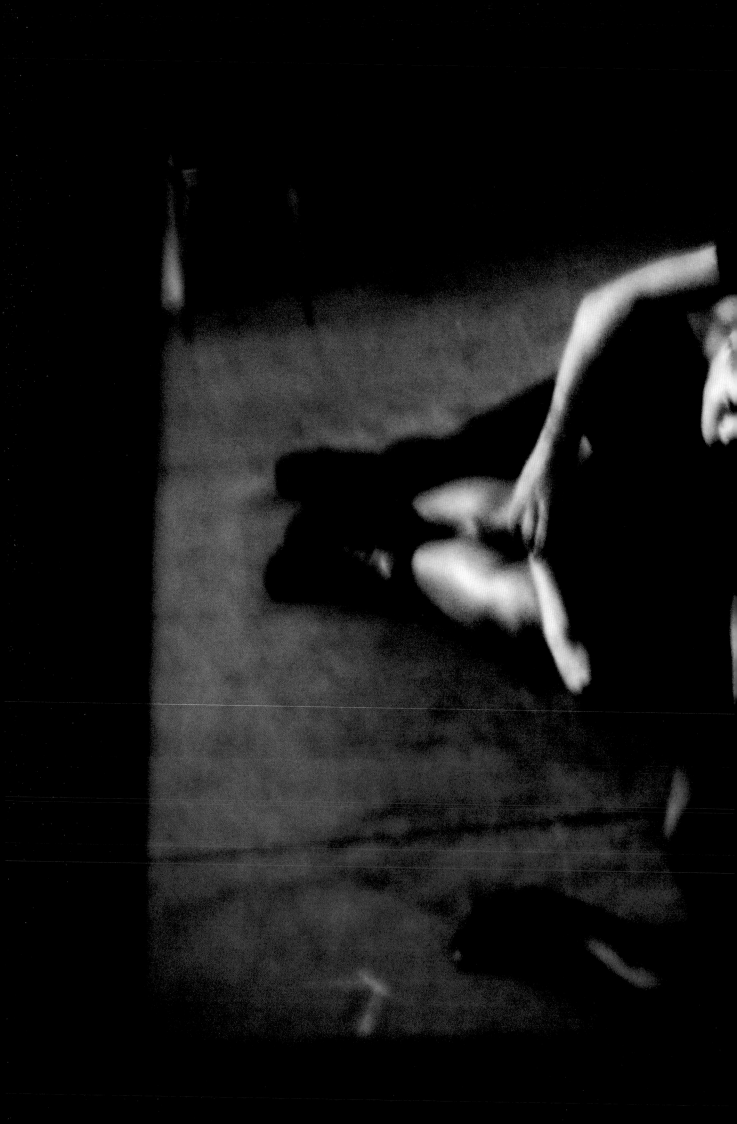

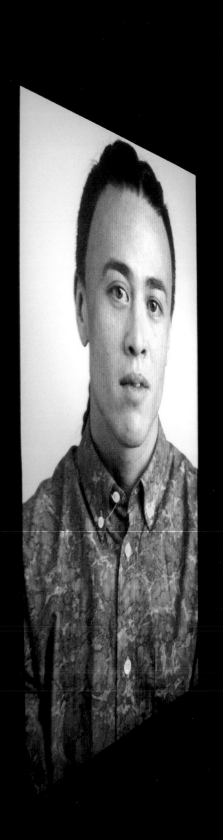

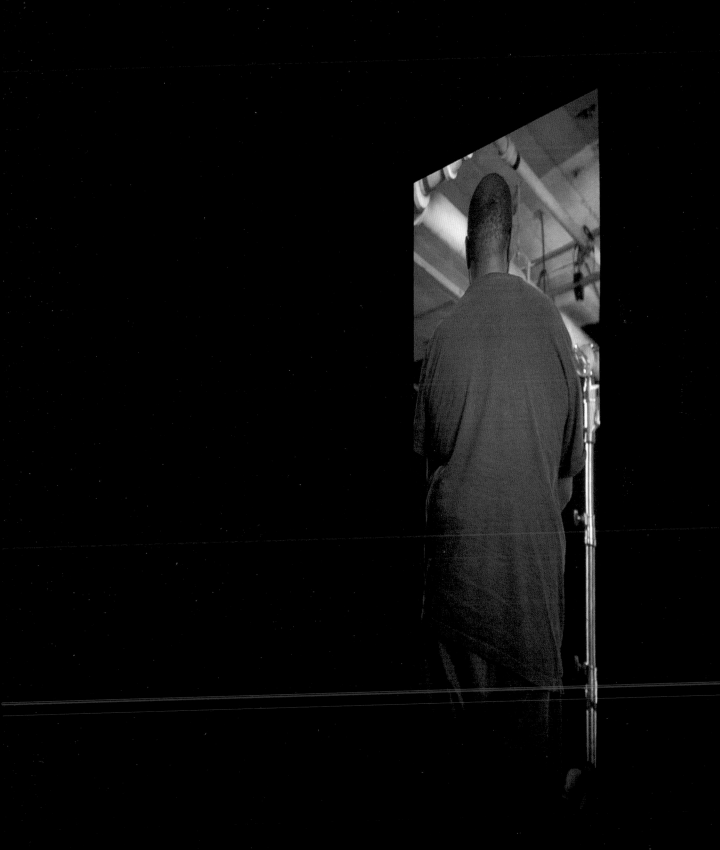

# A

## Spectacle

## And

## Nothing

## Strange

Dean Daderko

I:          Performing Otherwise

The works in *Double Life* blur the boundaries between staged narratives and real-world encounters, and they transform quotidian materials and situations into memorable experiences. They reference a range of temporalities and operate in spaces between the visual and performing arts, fiction and documentary, encounter and record, feeling and representation. Bodies in these works traverse numerous boundaries, and through this action both the physical and sociopolitical capacities of the term "movement" are offered for consideration. We are invited along for a ride that is, to quote Gertrude Stein, "a spectacle and nothing strange."

II:       Critical Action

Within visual arts contexts "performance" has long been perceived as the time-based activity of a live body or bodies presented for an audience. This is a lineage understood predominantly through the framework of theater. Art historians often cite precedents for performance art that date back to 1916, when the Dadaists—a group of artists that included Tristan Tzara, Hugo Ball, Emmy Hennings, Marcel Janco, Hans Arp, and Sophie Taeuber-Arp, among others—hosted riotous evenings of music, poetry, dance, and theater at the Cabaret Voltaire in Zürich, Switzerland. Though the content of the Voltaire's evening spectacles may have challenged audiences with an anarchic sensibility, the form these events took relied on the familiar and entertaining cabaret tropes of song, dance, and recitation.

Other historians trace performance's history to dramatic developments in 1950s Postwar painting practices such as Abstract Expressionism in the United States, and Gutai (variously translated as "embodiment" or "concreteness") in Japan. In his book *The American Action Painters*, Harold Rosenberg recalls that:

*At a certain moment the canvas began to appear to one American painter after another as an arena in which to act—rather than a space in which to reproduce, re-design, analyze, or "express" an object, actual or imagined. What was to go on the canvas was not a picture but an event.*[1]

Numerous sources refer to Pollock's painting process as a "dance" around the canvas, emphasizing the artist's rhythm and motion. The Japanese kanji character used to write "gu" means tool, measure, or a way of doing something, while "tai" means body. The word Gutai—body-tool, or body as tool—is a purposeful evocation of the bodily effort necessary to transcend boundaries. While Abstract Expressionism and the artworks created by Gutai artists embraced live action and offered vital formal innovations, practitioners in both movements continued to pursue object-based practices: their works didn't pose the kind of rupture from painting or sculpture that rejected previous forms. Instead, these artists' works continued art's linear narrative trajectory, even if they posed radical revisions to its formal language.

In the mid-1950s the field of anthropology began to experience a sea change of its own. Anthropologists had come to understand culture not as stable and static, but as an active and constantly evolving process of negotiation and adaption. It is within this context that anthropologists began to address "performance." Previously understood by anthropologists as a metaphor for theatricality, performance came to be employed as a heuristic principle that aided in understanding social behavior. Kenneth Burke developed theories of "dramatism," where theater is the meta-model used to interpret social situations in order to make sense of individual action. His colleague Erving Goffman, author of *The Presentation of Self in Everyday Life* (1959), was similarly interested in using theatrical metaphors to describe social relationships. Much like Shakespeare's dictum "All the world's a stage / and all the men and women merely players," Goffman conceded that we all play a part in how we present ourselves

in public; we act the part of the proud parent, the rejected lover, the angry customer. Victor Turner's contribution to the field is the notion of "social drama," which is less reliant on theatrical metaphors and more focused on the experiential dimension of symbolic actions.[2] Turner's formulation is, for me, the most compelling. Dependence on theatrical metaphor may come at the expense of the ability to recognize theater for, in, and as its own reality.

Thus, in what is known within anthropology as "the performative turn," the notion of society-as-theater evolved into a broader category that considers all culture as performance. Performance here serves the dual function of acting as metaphor *and* analytical tool; it is the frame through which cultural and social phenomena are viewed, and the means by which they are interpreted.

Understanding performance as a site of action in which the ritual, symbolic, and actual function simultaneously strikes me as extremely productive; it is the ideological basis from which this exhibition proceeds.

III:      Redress Rehearsal

*Brazil* is the first section of poet Elizabeth Bishop's book *Questions of Travel*. Its ten poems "provided, or were thought to provide, a dreamy poetic recapitulation of colonialism in Brazil from the point of view of a displaced and homeless but definitely privileged lesbian traveler who might be herself a sort of colonizer."[3,4] In the poem "Questions of Travel," Bishop recalls disembarking from a boat in the Brazilian port:

*Is it right to be watching strangers in a play*
*in this strangest of theaters?*
*What childishness is it that while there's a breath of life*
*in our bodies, we are determined to rush*
*to see the sun the other way around?*[5]

Bishop's acknowledgment of the sense of conflict she experiences during this event is illuminating. Her turn of phrase "we are determined" makes it clear that she recognizes herself as a potential colonizer, while at the same time recognizing the natural curiosity that drove her to travel. Her poem embodies her deeply felt sense of conflict, allowing her feelings to be shared publicly by offering them a concrete form.

The form known as performance art is rife with embodied provocation. As early as the 1960s, artists including Allan Kaprow, Lee Lozano, Yoko Ono, Yvonne Rainer, Carolee Schneemann, and Jack Smith in the United States, and further afield Joseph Beuys, Gunther Brus, Lygia Clark, David Medalla, Hélio Oiticia, Gina Pane, and Franz Erhard Walther began—as many other artists did—to create ephemeral, temporal events in which and through which they posed and explored questions of personal and political import. While the staging of these events may have included spoken and written word, music, sound, costumes, and props, none of these items were requisite. Performance's only real requirement is presence—a presence that desires a response.

Efforts to understand an artwork often begin with an attempt to locate it within a particular aesthetic or stylistic continuum—we "find a place for it." Performance is not dependent on objects, nor does it necessarily produce them. As an ephemeral and temporally finite activity, performance can be difficult to situate in a formal spectrum. The ephemeral, temporal act *is* performance's final product. As such, the messages artists share in performances are often as ephemeral as the sources that inspire them; feeling is embodied, and the invisible is rendered visible *for a time*.

In the 1960s (as now), artists disillusioned by the translation of their ideas into capitalized products turned to performance because they appreciated the form's resistance to commodification. At that time, the Vietnam War was criticized, and gender bias was acknowledged by those advocating for equal rights. Performance practitioners came from a diversity of backgrounds. They included visual artists, actors, poets, dancers, writers, and musicians, though they could just as easily have been secretaries, chefs, soldiers, or graphic designers with urgent messages to share. The discourse here was not predicated on mastery; desire and urgency were more immediately identifiable. Performance embraced experimentation, and its history had yet to be written; the form itself was present—a presence—and it came to tell a story.

According to the estimable theorist and historian Peggy Phelan, performance art draws from three distinctly different narrative traditions: the history of theater, in which performance is a counterpoint to realism; the history of painting, where it gains force and focus after Pollock and Action Painting; and the history of anthropology, where performance represents a return to investigations of the body (as evidenced in shamanic and healing practices).[6] No matter its derivation, performance relies on an animating presence.

Phelan's last historical attribution is, for me, particularly compelling: the nomination of anthropological concerns as a precedent for performance implies a genealogy that isn't predicated on the linear development of modern artistic practice. This isn't to say that performativity rejects art historical lineage. Rather, I am interested in the fact that it expressly accommodates—that it turns toward—other sources of reference and inspiration, wherever these exist in the world. Performance adeptly explores sociality and lived experience, producing relations to "the real" just as convincingly as it establishes connections to the poetic, the metaphoric, the mythic, and the fictional. It allows distinctly different idioms—politics and poetry, for instance—to exist simultaneously. And it can draw these discourses together without establishing a sense of hierarchy between them. In a pluralistic sense—as with Turner's "social drama"—performance simultaneously *represents* the real, and *is* real.

## IV.  Ideas, Embodied

### Other Voice

Divergent realities coexist when the actors in Wu Tsang's film *For how we perceived a life (Take 3)* (2012) speak monologues delivered by the subjects of earlier documentary films. Tsang appropriates dialogues from *The Queen* (1968), a chronicle of a 1967 drag pageant in New York City, and Jennie Livingston's legendary, era-defining documentary *Paris Is Burning* (1990), which brought "voguing" to mainstream audiences through its exploration of New York City's underground ball culture. Additional dialogue in *For how we perceived a life (Take 3)* was derived from two less visible sources. One of these is an interview Tsang conducted with Hector Xtravaganza, Grandfather of the House of Xtravaganza, one of the longest continually active "houses" to emerge from New York's underground ballroom scene.[7] Tsang also located additional content in archive materials he found during research visits to the University of California Los Angeles's Film and Television Archive, which holds a collection of more than 86 hours of outtakes that were not included in Livingston's feature film. The specific passages of speech Tsang chose were scripted and shared with a group of actors he cast. They recorded this dialogue in their own voices. Their (re)recordings are the basis for two separate works: a film and a live event.

*Double Life* includes Tsang's film *For how we perceived a life (Take 3)*, in which five actors, all dressed in black clothing, move about a low-lit, raw industrial space while lip-synching their lines. Shot on a single 400-foot-long roll of 16mm film, this work is projected as a loop. In its opening scene, the actors—all multi-racial or people of color—appear as a sensuously massed pile of bodies, reciting a litany of desires. Some of the requests are ordinary: "I want a car." "I want

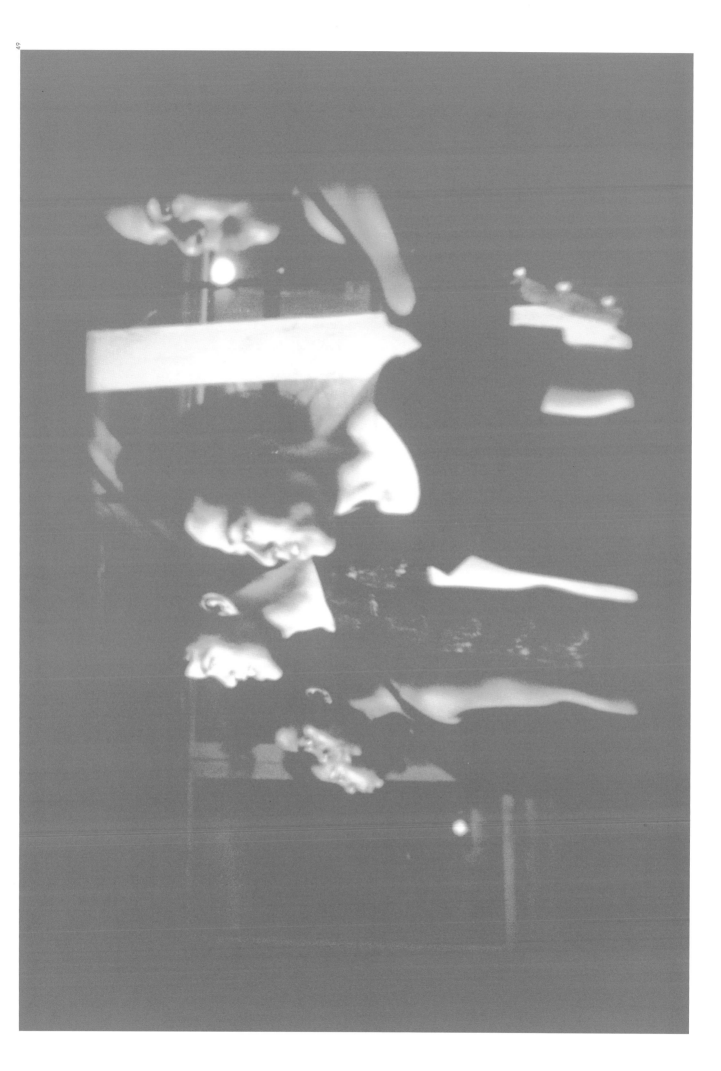

to get married in church, in white." "I want to be rich." As we watch the actors disentangle their bodies, we begin to hear requests that betray a sense of disillusion: "I want a nice home, away from New York. Up the Peekskills or maybe in Florida, somewhere far, where nobody knows me." "I want my sex change." "I want my name to be a household product."

When an actor who appears male-bodied delivers an aggressive, accusatory diatribe centered on the loss of a beauty pageant, we can assume Tsang's casting deliberately intends this gendered friction. The tension is thickened through the use of a technique Tsang calls "full body quotation," a mimetic channeling of voices that is task-based, though it appears consciously reflective. In reality, the actors are re-engaging with dialogue they recorded in earlier sessions, either through lip-synching, or by hearing it on wireless earphones and repeating it simultaneously. Both methods produce striking results. The actors' labor at listening appears to interrupt the demonstration of feeling, turning them, in a sense, into "human playback devices."[8]

In a previously published interview, Tsang offered this reflection on the perceptions embodied in language:

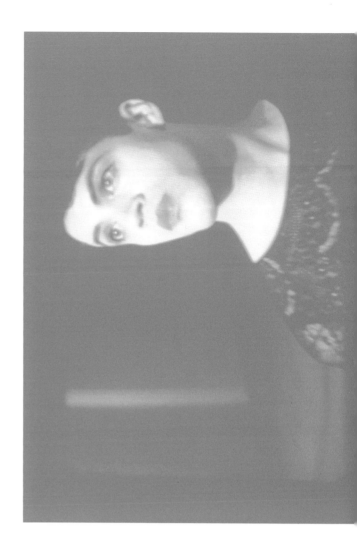

In underground scenes, we often have a deep sense of what is "outside" and "inside" as well as humor and irony, what is offensive, and what is pushing the boundaries, etc. But the terms are constantly shifting, depending on who is speaking, and also as they become re-encoded by the group. Everything bears a relation to appropriation in this way. Maybe being transgender and multi-racial has influenced my thinking on this because there are few social codes that feel "mine." I'm usually reaching for things out of a desire to claim, or a need to pass.[9]

The performative appropriation of language in *For how we perceived a life* (Take 3) effects a subjective shift. Do the thoughts we are hearing "belong" to the actor? Can they or might they? Tsang plays with assumptions about identity—especially as they relate to race and gender—through the actors' character(istic) (re-)embodiment. Speaking someone else's words doesn't allow us to "know" them, of course. Instead, Tsang strategically stages these proximities—between the actors, the subjects whose words they are (re)speaking, and viewers—to lead us to assess our own biases and the judgments we make about people.

Again, to quote Tsang:

I learned from Mary Kelly that a 'project' is a line of questioning that intersects with a broader political moment... Being a grassroots organizer has also trained me to think in terms of "transformative" education—which puts equal emphasis on content, purpose, and approach. So I give equal attention to the questions "What am I saying?", "Why am I saying this?" and ultimately "How am I saying this?" which leads to the form.[10]

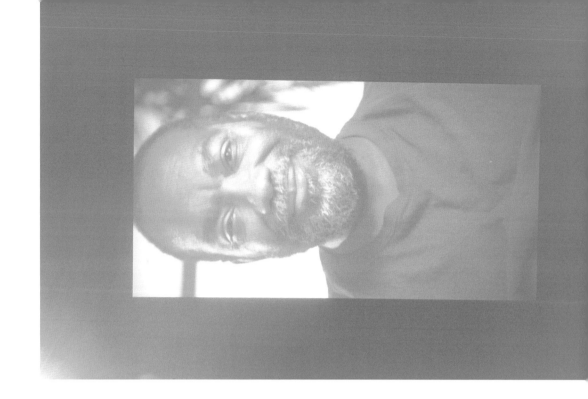

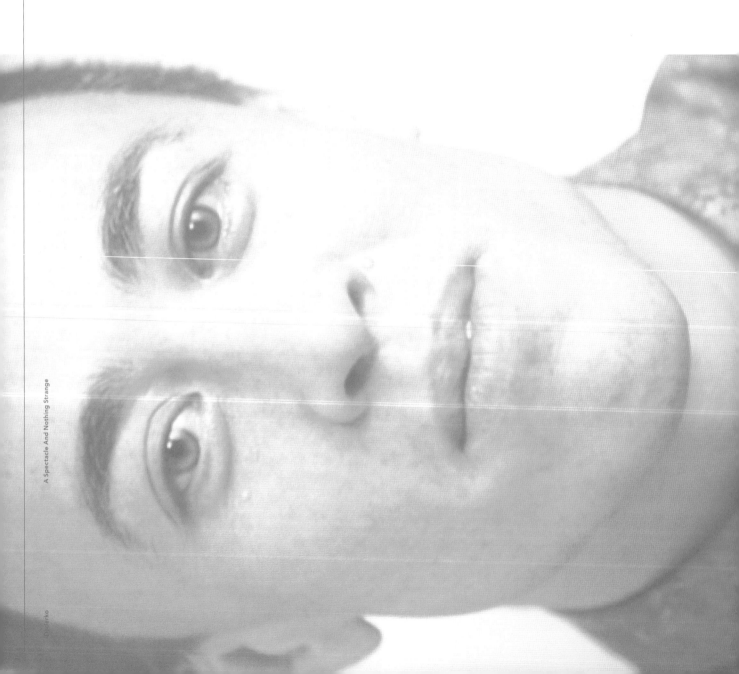

Just when *For how we perceived a life (Take 3)* appears to be approaching its narrative resolution, the looping film delivers us back to where we started; this is an apt metaphor for the way that race- and gender-based discrimination remains culturally unresolved today. Tsang doesn't peel back the layers that surround how identity, representation, and exploitation function so much as he displays these multiple layers to us, asks us to dig deeper into them, and leaves us to confront them in their full complexity. Tsang understands that resolving these problems is beyond his control. Instead, by exposing the predicament, he helps us to identify sites of conflict and vulnerability more effectively, so that we might address them ourselves.

The live performance *Full Body Quotation* (2013) makes it clear that *For how we perceived a life (Take 3)* is a performance-for-the-camera.[11] In *Full Body Quotation* the performers enact the same lines in front of a live audience. But here, instead of lip-synching, they listen to the lines of dialogue they are about to recite on tiny wireless earbuds. Imagine hearing a recording of your own voice and having to recite the words you have just heard with zero delay, all while continuing to listen for the next ones: a cacophony. *Full Body Quotation* focuses on the exteriorization of an interior voice through a process that couples memorization with (nearly) simultaneous recitation. The inside is made visible, embodied.

These two methods of delivery—live performance in *Full Body Quotation* and performance-for-the-camera in *For how we perceived a life (Take 3)*—demonstrate that each methodology possesses a particular acuity: the looping film allows us to watch the group's action repeatedly, and at a slight remove; the live event is notable for its ephemerality, temporality, and intensity.

The speech act is also the focus of a new work commissioned for this exhibition—*Miss Communication and Mr:Re* (2014)—that Tsang created with the poet and cultural theoretician Fred Moten. It builds upon an earlier collaboration that was realized as a live event, and re-imagines it in the form of a two-channel audio and video installation.[12] The work draws on the nearly ubiquitous experience of listening to voicemail messages. In doing so, Tsang and Moten explore the consequences of inference, projection, and temporal lags on narrative comprehension. Tsang and Moten each recorded a channel of video and audio in which they speak and respond to one another, without ever directly speaking with each other.

At regularly scheduled daily times over the course of a two-week period, Moten and Tsang (who were then based in time zones nine hours apart) called and left each other voicemail messages. Each of their recorded messages provided subject matter that subsequent messages developed: a conversation separated by space and time. In a sense, they performed their missed connection for one another. The messages became the raw material that the artists worked with. After agreeing to a time parameter of 15 minutes, they excerpted dialogue from the messages left by the other caller. The independently edited tracks were then woven back together and mastered in stereo to become a single, multi-layered and evocative audio track in which each voice arrives from a different direction. Heard on wireless headphones, Tsang's voice enters one ear, while Moten's enters the other.

The visual components of *Miss Communication and Mr:Re* were videotaped using a device called an Interrotron. Developed by the lauded documentarian Errol Morris, the technical format of the Interrotron is much like that of a Teleprompter—the tool politicians and newscasters use because it allows them to read text and look into the camera at the same time. Instead of scrolling

text, the Interrotron displays the image being recorded by the camera as a live-feed. This connection between the camera and the subject being filmed generates the impression that the subject is speaking directly to you; the camera's view and what the viewer sees are interchangeable. According to Morris, the Interrotron "creates greater distance and greater intimacy. And it also creates the true first person."[13]

*Miss Communication and Mr:Re*, as its title suggests, explores the lacunae of language where imagination and intuition are employed to offer a sense of completion and closure. If, as Joan Didion has said, "we tell ourselves stories in order to live," then this work explores the ways in which we think through our own personal experiences in order to make sense of another individual's feelings.

As it is presented in *Double Life*, video images of each artist's head are projected onto opposing walls. We do not see their mouths move, but we do see each of their faces portray a range of emotions. By looking directly at the camera, it appears that they are looking at each other, or, as we enter the space between them, at us. Coupled with the weightless immateriality of the video projections, the audio track in which the pair appears to talk to each other—without actually engaging in a dialogue—reinforces both their division and desire to connect. As viewers positioned between the characters in this unfolding drama, we occupy a space that is at once physical and conceptual, actual and imaginary. We cobble together a story for this pair out of the words we hear. We find ourselves between two subjects, two stories, and two projections. The valence of "projection" here encompasses both the physicality of the videos and an act of emotional calculation. Called upon to make sense of this record, we discover the ambiguities and possibilities of both language and agency.

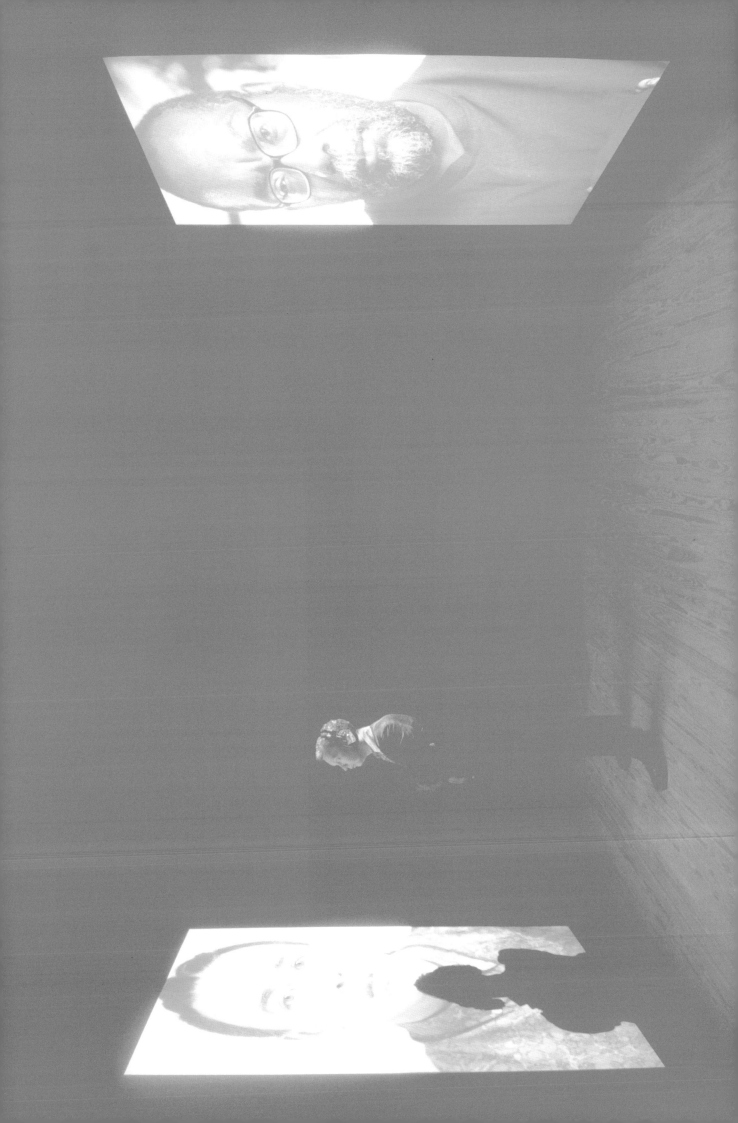

Bel began speaking with a particular *corps de ballet* member named Veronique Doisneau. During these interviews, he listened to Doisneau recount her personal and professional details that marked her experiences as a ballerina. Their interviews were transcribed, and reviewed and excerpted by Bel. They were then turned into a script that was given to Doisneau. The script is Bel's; the stories are Doisneau's. At his invitation, she takes to the stage to perform this "solo."

The information recorded in the introductory portion of Bel's script is fairly standard: at the time of her interview with Bel, Doisneau was 42-years-old, and the mother of two children, ages 6 and 12. She earned a salary of 3600 euros ($4463) per month working with the Paris National Opera's ballet company. The ensuing narrative offers further specificity: Doisneau's position in the company was that of a *sujet* [subject], which indicates her ability to dance solo roles in addition to those assigned to *corps* members; it also reveals that at the age of 20, Doisneau underwent an operation for a herniated disc, during which an entire vertebra had to be removed from her spine—her doctors doubted that she would regain full mobility.

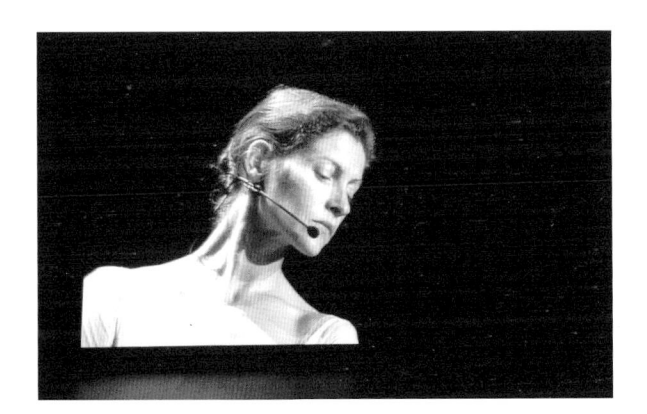

## Spoken Dance

Paris-based choreographer Jérôme Bel's work demonstrates inextricable links between dance and language, and politicizes them. *Veronique Doisneau* (2004) and *Cédric Andrieux* (2009) are two works in a series of eponymously titled solos through which Bel foregrounds the figures of the dancer. His collaboration with each performer exposes the politics that structure their shared field.[14]

In 2003 the Director of Dance at the Paris National Opera, Brigitte Lefèvre, invited Bel to create a long-term project with the company. After some consideration, Bel chose to focus his attention on the *corps de ballet*—the ensemble company members who appear onstage not as soloists, but in support of them. The synchronized movements and stage positions of *corps de ballet* members are meant to enhance the audience's view of soloists and principal dancers; as such, these artists often occupy the theatrical background. The politics of this situation intrigued and inspired Bel.

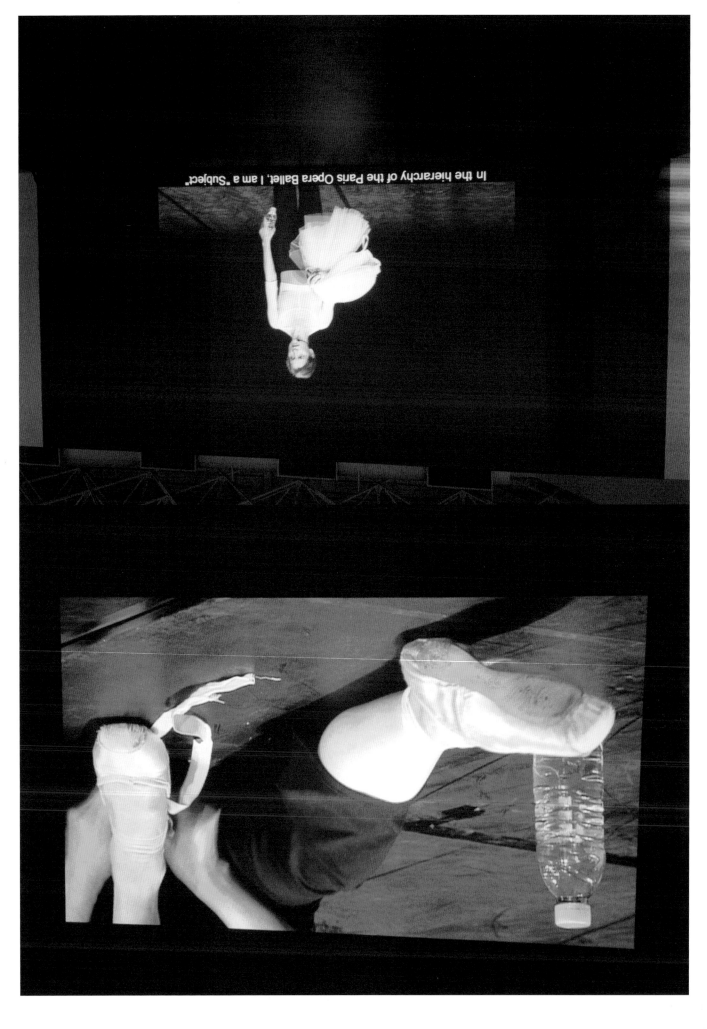

"In the hierarchy of the Paris Opera Ballet, I am a "Subject"."

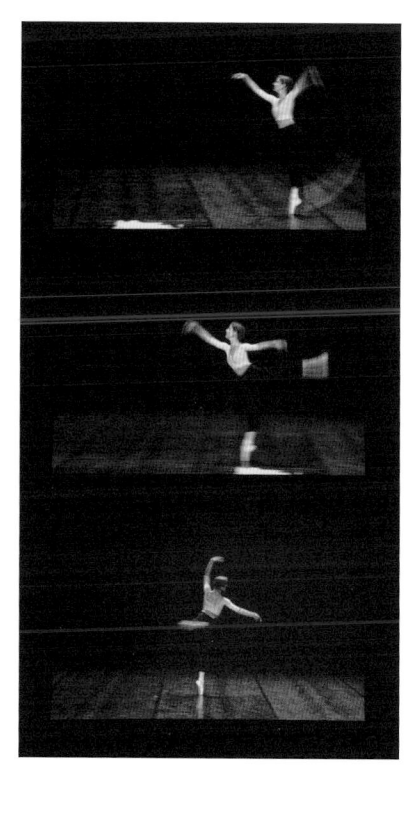

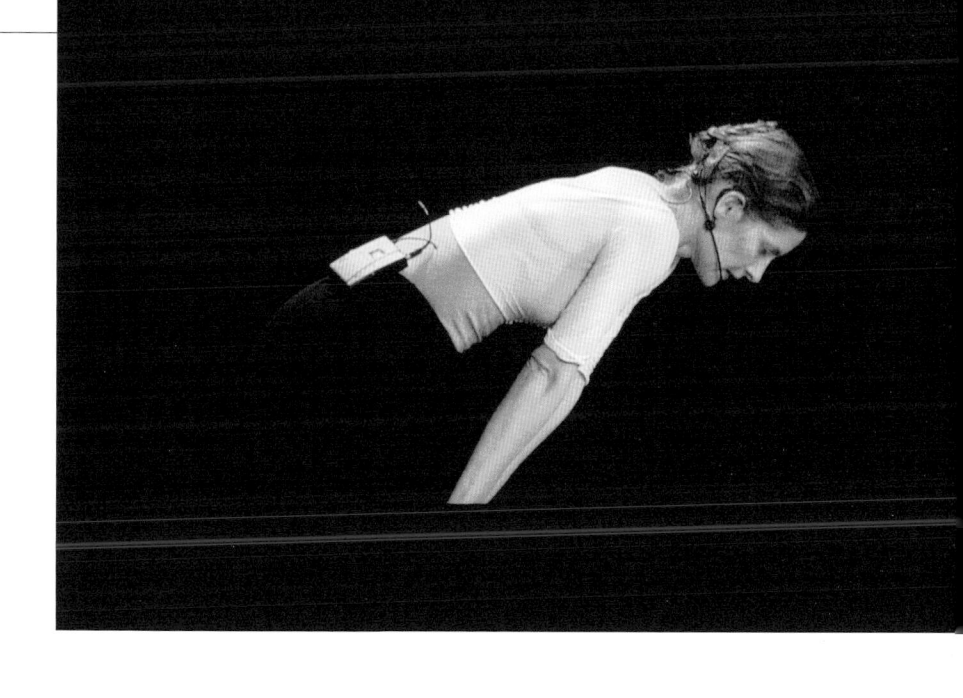

As she continues her story, Doisneau offers anecdotes about experiences she feels have informed her practice as a dancer. As she shares this information, our perception of "what it takes" to be a dancer grows in tandem:

> Meeting with Rudolf Nureyev was fundamental for me... He gave us the idea that it was through the mastery of the language of dance that emotion is created. Above all, he told us to respect the sense of movement and not interpret it.

and:

> The ballets I don't like to interpret are from Maurice Béjart and Roland Petit... I learned a lot from Merce Cunningham: to dance in silence and be attentive to other dancers' rhythms.

Importantly, Doisneau performed this script onstage at the Palais Garnier—the primary stage for the Paris National Opera's ballet company. It was presented on September 22, 2004, eight days before her official retirement from the company. Doisneau's first and only public presentation of the solo Bel created for her was also to be the last dance of her professional career. As such, Bel decided to record it. *Veronique Doisneau* (2004) is unique among his series of dancer "portraits", as it is the only one that exists in video; all of Bel's other portrait-works continue to be staged.[15]

Doisneau is the only figure on stage for the entirety of this half-hour performance. As we watch, we realize how unaccustomed we are to hearing dancers speak. The ballerina is dressed in dark workout tights and wears a wireless microphone that allows her freedom of movement while speaking directly to the audience, breaking the fourth wall. There is no contrivance of fantasy on this evening: brightly, evenly lit and void of props, the stage feels barren. Bel challenges us to focus on the issue at hand. The blankness of the stage stands in stark contrast to the red velvet seats and gilded boxes of the horseshoe-shaped Beaux-Arts theater. With the full house of spectators gathered to view her recital, Doisneau appears incredibly vulnerable.

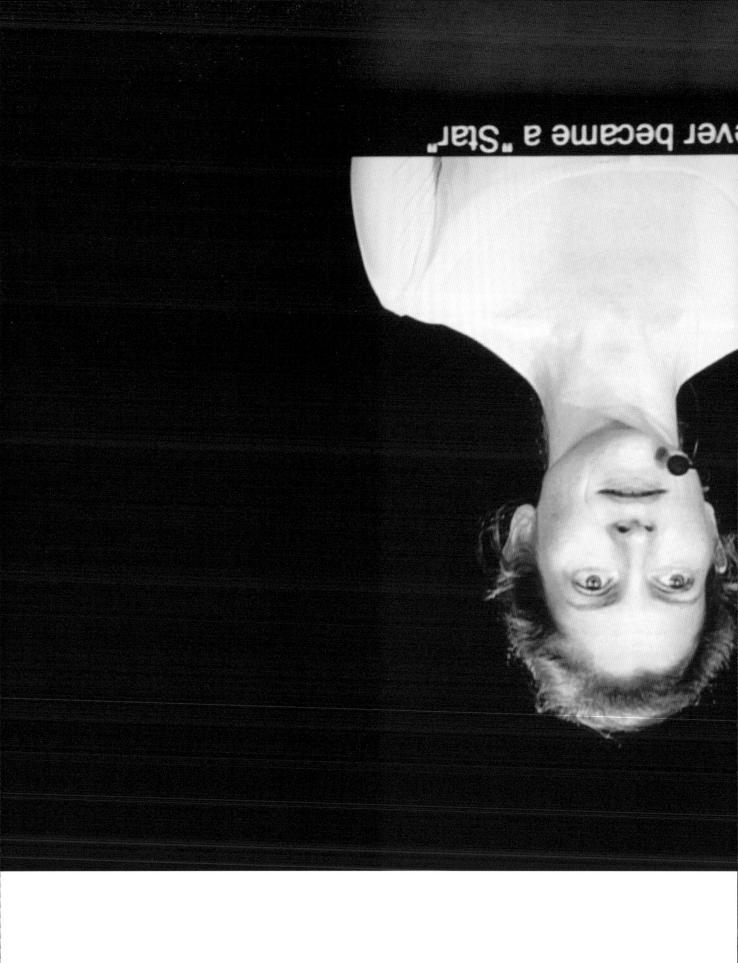

...ever became a "Star."

Peggy Phelan has said that performance's only life is the present.[16] We're made acutely aware of the energy Doisneau exerts while dancing; following one passage of movement, the microphone that has been amplifying her voice also picks up her labored breathing. She bares herself to us. She talks about about the frozen poses required of the *corps de ballet* during Swan Lake:

> *One of the most beautiful things in classical ballet is the scene from* Swan Lake *where 32 female members of the corps de ballet dance together. But in this scene, there are long moments of immobility—the poses—when we become human decor to highlight the stars. And for us, it is the most horrible thing we do. Myself, for example, I want to scream, or even leave the stage.*

If we think Doisneau could be given to exaggeration, her demonstration of the scene confirms that she is not; watching the delicate positions she assumes with her limbs held out from her body for extended periods of time, we can feel how torturous this action must be.

Over the course of the performance, a sense of melancholy emerges. It is understandable, given Doisneau's impending decampment from the company. "I never became a star…The question never came up. I think I was not talented enough. And too fragile physically." As Doisneau recounts successes, failures, experiences, and passions, we come to know the internal motivations that drive her. *Veronique Doisneau* offers a revelatory perspective on the emotional complexities, tolls, labor, and achievements attendant to a life in dance.

Bel's protagonism self-reflexively exposes the hierarchies that the

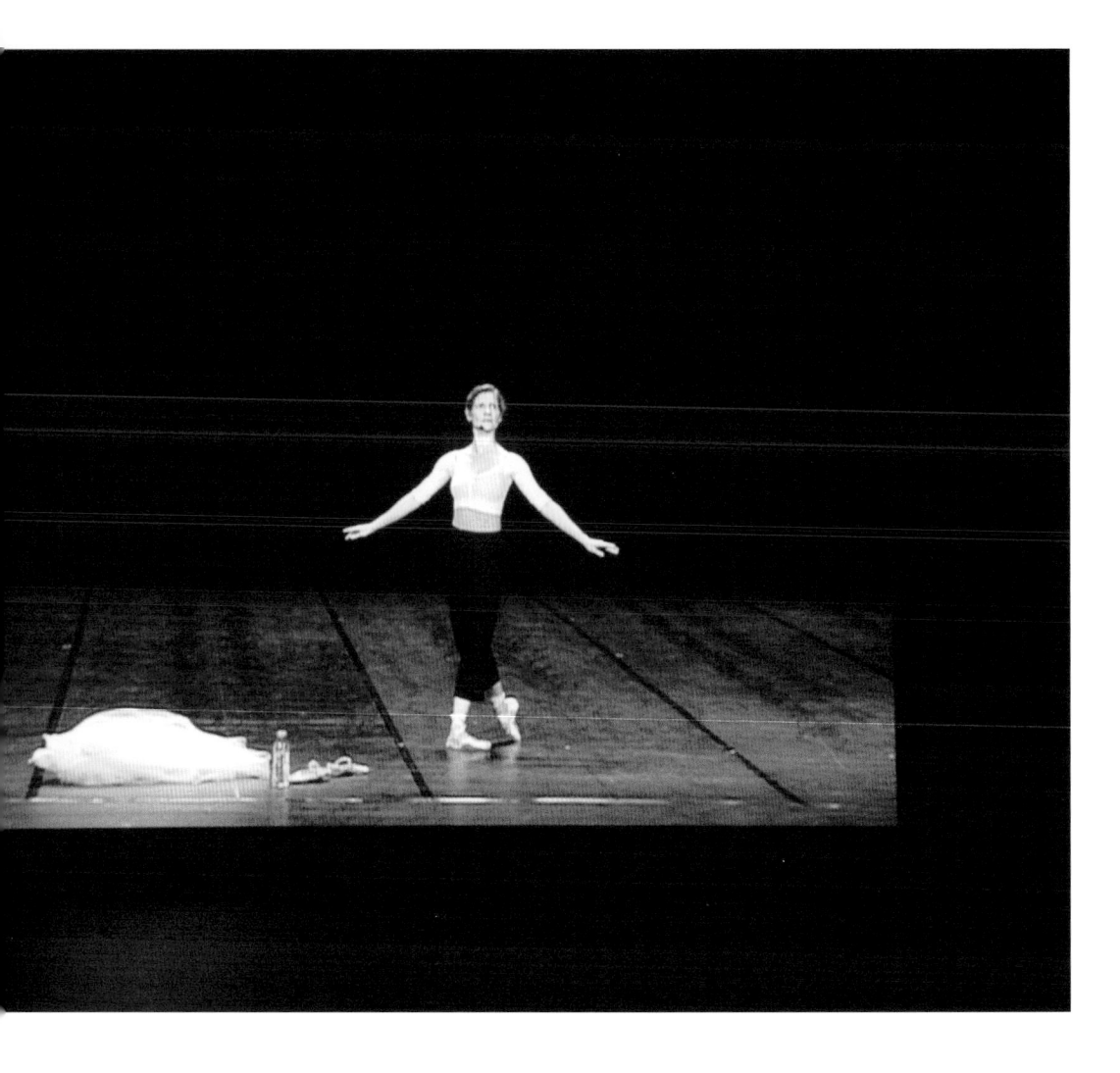

dance world has come to accept, and refutes them. He recognizes, for example, the baseless hierarchy that privileges the choreographer's staging over the dancer's execution. *Veronique Doisneau* and *Cédric Andrieux* both chronicle the sense of alienation that such unnecessary hierarchies establish, and work to dismantle it, leveling the dance floor.

Modern dance developed as a rejoinder to ballet's primacy as a concert dance form, and confronted ballet's perceived rigidity with emotive movement and a commitment to stylistic diversity. Modern dance, however, was not immune to a formal ossification itself. In his introduction to *Exhausting Dance: Performance and the Politics of Movement*, writer André Lepecki observes that, even today, "dance ontologically imbricates itself with, is isomorphic to, movement." Lepecki notes the reticence of some dance audiences, and even practitioners themselves, to accept aspects of dance that are not movement-based.[17] Seen in this light, it becomes clear that even innovators like Merce Cunningham were not quite prepared to accept a

conceptualization of dance that was not predicated on movement. "For Cunningham the subject of his dances was always dance itself."[18] As such, Bel's work *Cédric Andrieux* resonates as strategically aimed: Andrieux spent eight years dancing with the Merce Cunningham Dance Company, and by creating a solo for him, Bel teases out a conversation on a practical limitation of American modern dance.

Bel's productive agitation directly challenges normative conceptions of dance as a movement-based practice by bringing a range of conceptual approaches to bear on it. Because dance presentations are temporal events, Bel understands language as one of the primary methods through which dance narrative is shared. Compared to mediated forms that require other technologies, language communicates ideas rather immediately. This language-based approach, coupled with Bel's embrace of non-movement-based choreography, demonstrates how he has politicized (his) dance practice in order to risk a form of meta-commentary that expands the field of dance conceptually and practically.

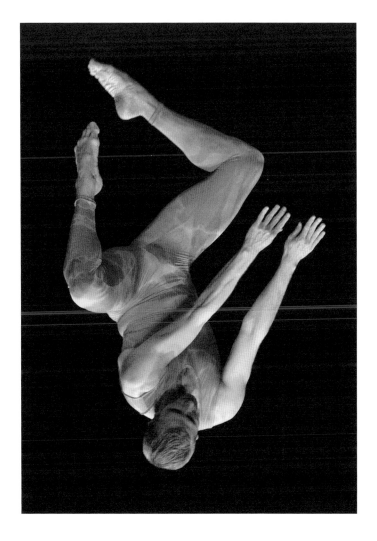

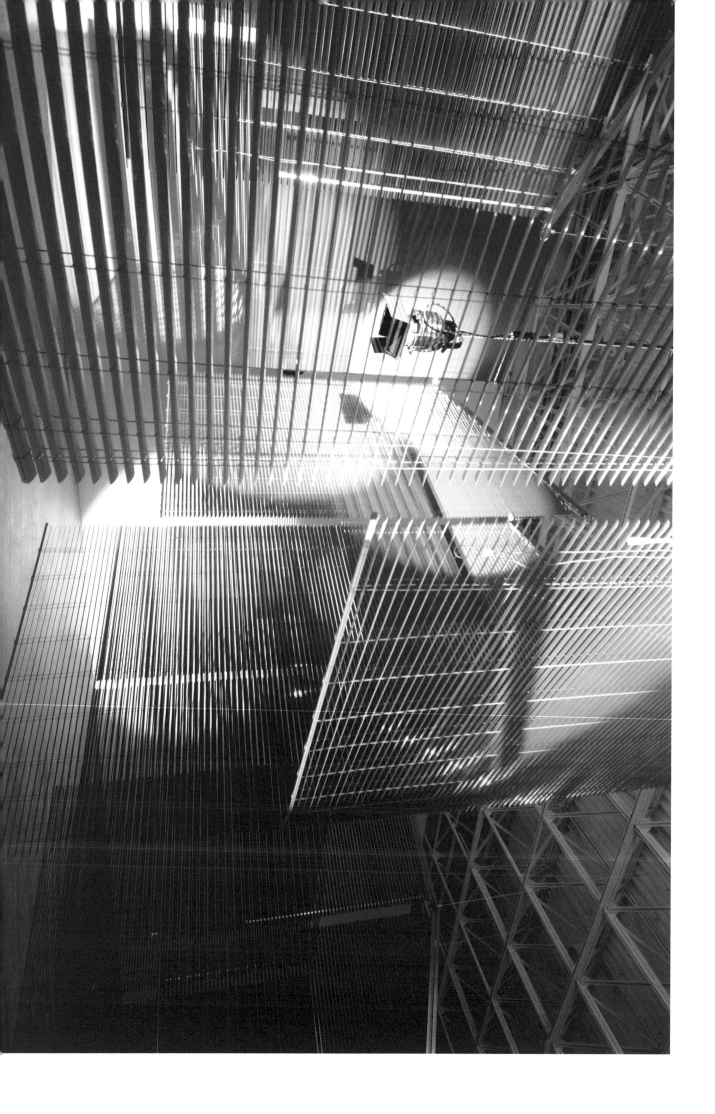

## Feeling Materials

*Mountains of Encounter* (2008) by Haegue Yang is a labyrinthine sculptural environment constructed primarily of custom-made Venetian blinds. At just over 16 feet wide, 34 feet long, and 17 feet high, its sheer volume is impressive, though its building blocks are humble. Comprised of four distinct layers of blinds suspended in proximity to each other, the work creates a series of passageways through which viewers can pass.

In the most complex of the four layers, five distinct panels of blinds meet each other at ninety-degree angles to form a simple spiral. The remaining three layers are each composed of two panels that also meet at right angles. All four of these layers are oriented along a common central artery. In this particular installation at CAMH, first encounter two of the right-angled layers nested into one another like double parentheses, then the spiral layer, by the fourth right-angled layer, which closes the parentheses.

An assessment of *Mountains of Encounter* constructed solely on the act of looking at its physical and material characteristics would deny the work a layer of narrative richness. In fact, Yang's inspiration for this work can be traced to a series of clandestine meetings that took place in the 1930s in a mountainous region in northern China known as Yan'an. The specific narrative Yang engages with in *Mountains of Encounter* took place within a broader geopolitical context: in 1937, the United States had yet to enter into World War II, but many eyes turned to the region when China and Japan entered into the Second Sino-Japanese War. This war was the result of a decades-long imperialist policy with which Japan aimed to politically and militarily dominate China in order to secure access to vast raw material reserves of coal and iron ore, and economic resources like food and labor. As a newly risen power that was quickly modernizing, Japan recognized that maintaining control of the Korean Peninsula would help to secure its interests in a region that was destabilized as a result of internal conflicts in China.

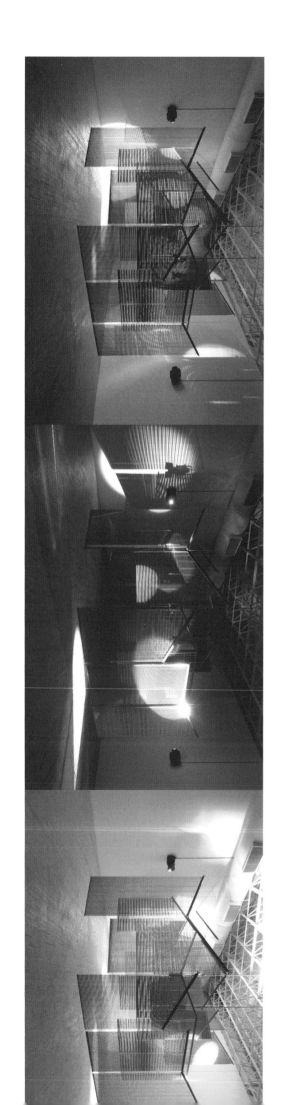

The story that inspired Yang took place within this context. We can trace its origins to 1931, when the American journalist Helen Foster moved to Shanghai to take a position working at the US Consulate. Almost immediately after her arrival, she met Edgar Snow, another journalist, with whom she began a relationship. They married in 1932, and a short time later the couple moved to Beijing (now Beijing) to begin teaching at Yenching University. Since some of the students in Foster Snow's journalism classes were involved in the Communist underground, she came to know about the efforts and conflicts of the Party in which they were involved.

In 1935, Foster Snow traveled to Yan'an in order to report on the Long March—the military retreat

taken by the Red Army in order to evade pursuit by Chinese Nationalists—that had terminated there. Yan'an subsequently became a stronghold for the Chinese Communist Party, not least for its remote and isolated mountain location.

The angles of *Mountains of Encounter's* hanging frames zigzag between floor and ceiling; with a bit of imagination, it is easy to see them as a horizon of craggy peaks. Unlike earthbound mountains, Yang's appear to resist gravity's force. Discrete wires that are all but invisible connect each hanging structure to the ceiling, and the Venetian blinds cascade from these suspended frames. Some of the blinds stop just above the floor, and others hover overhead. While the bottoms of some blinds are knee-

height, others offer enough clearance to pass under them. This variation in height sets up a pleasing rhythm that invites us into the work, though "inside" and "outside" are contingent terms here.

*Mountains of Encounter's* impression of lightness is the result of a conscious decision by Yang made that the leading blinds appear equally half-open and half-closed when viewed from standard eye level; this subtle adjustment helps to dissipate their mass. As such, they act simultaneously as walls and as windows. We look *through* Yang's skeletal blinds, as well as at them. The scene they create is as atmospheric as mountains rising out of a haze. This ambience is pushed further by the constantly shifting moiré

Korean nationals who had come to China to receive military training from the Communists. Of them, the charismatic Jang Jirak stood out above all the rest. She recognized him as an important leader within the Korean resistance movement, and observed that:

*He had an independent fearless mind and perfect poise… And under the surface, though he was gentle-mannered and reclusive, there was power… I felt that he had not only no fear of death or killing but was morally and intellectually incorruptible and without evasion.*[19]

After her first interview with Jirak, Foster Snow requested another, and then another. While recording Jirak's compelling stories, Foster Snow decided that his biography was worthy of a book all its own. She realized this goal with *Song of Ariran* (1941), in which she identifies Jirak as Kim San. Foster Snow's interviews were all conducted in clandestine locations because Jirak needed to stay a step ahead of the Japanese intelligence forces searching for him. Indeed, out of concern for Jirak's safety, Foster Snow agreed to delay the publication of his story for two years after she had written his biography. Because Jirak was on the run under a concealed identity, it became difficult for Foster Snow to track his whereabouts, and she lost touch with him. He was assassinated in 1937. Today, Koreans recognize the inherent patriotism of Jang Jirak's efforts.

Four luminous circles projected by motorized spotlights glide constantly over the blinds. Their ceaseless motion creates a play of light, shadow, and reflection, reminding us of Jirak's fugitivity. The roving spots create a drawing in space that animates the entire structure, uniting each of its four sections in a radiant, totalizing embrace. The contrasting whiteness of the spots makes the red appear even redder, and can, at times, be a blinding force. In the work's spiral center, two floodlights aimed at the floor dim and brighten in alternation, creating soft pools of light that grow and recede as if they are breathing. Might these represent the dialogues between Jirak and Foster Snow?

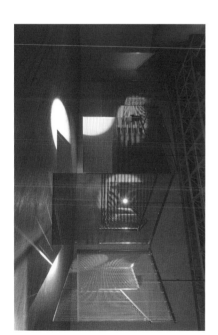

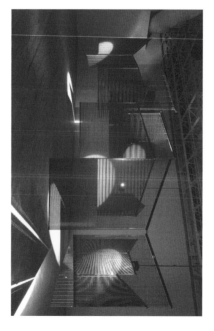

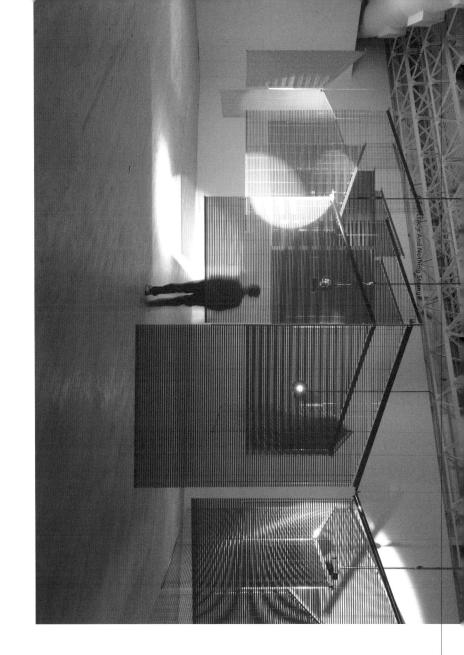

patterns one encounters while moving around the work. Since each blind's slats are parallel and equidistant from on another, they create alternating light and dark zones. Seen through other blinds at other angles, the interaction of each light and dark pattern generates the distinct impression of a third pattern that shifts with us as we move. This effect feels hallucinatory, and challenges our perception of the blinds as stable physical objects; their mass can appear to be in flux, mercurial, dissipating.

Helen Foster Snow traveled extensively in Yan'an in the mid- to late-1930s, publishing reports under the pseudonym Nym Wales. Many of the interviews she conducted were anthologized in her books *Inside Red China* (1939) and *Red Dust: Autobiographies of Chinese Communists* (1952). During her travels, Foster Snow met a number of

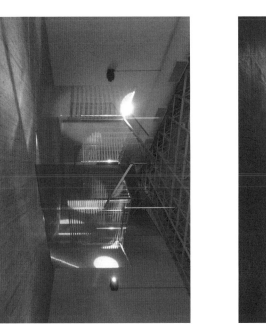

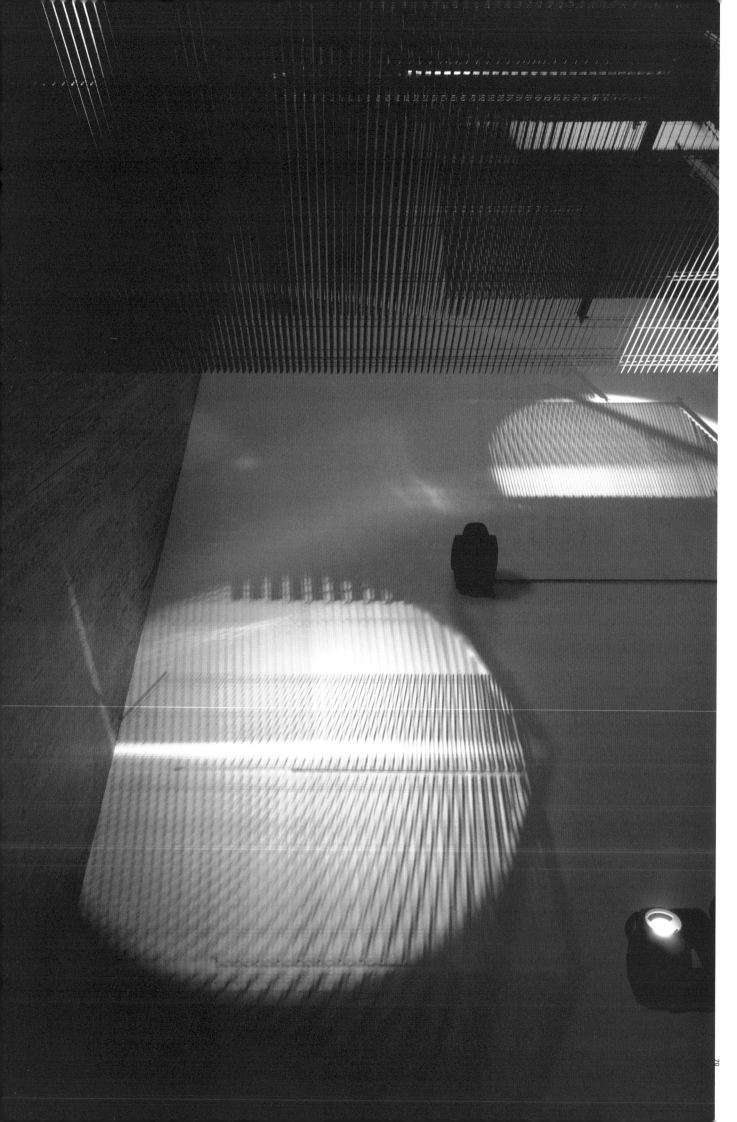

If *Mountains of Encounter* abstractly manifests San/Jirak's and Wales/Foster Snow's story, it is certainly not reliant on a knowledge of their history to create a memorable experience. An experience with the work is an event. The knowledge of this history allows us to "read" the brightening and dimming pools of floodlight on the floor as whispered exchanges that took place between the two main protagonists in the narrative. Here, the color red can evoke the color of revolution, the color of blood and vitality, and the color of the Chinese flag; red is also synonymous with Communism. The roving spots can be seen as figures on the run, while also resembling an inversion of the "rising sun" of the Japanese flag. Looking through the half-open Venetian blinds creates atmospheric moirés; one can also read into them an allusion to the secretive nature of Jirak and Foster Snow's encounters—think of the dramatic striped lighting of film noir productions. The blinds' permeability and the open volume of the structure also demonstrate that "inside" and "outside" are relative and contingent terms related to one's own position, whether it be physical or conceptual.

These readings convey the multiple possibilities available in an abstract sensibility that Yang has developed in her practice. In her opinion, conventional narratives are capable of illustrating a single image. To quote the artist:

What fundamentally lies beneath these narratives can be shared without being told as a story. For me, abstraction is not anti-narrative, it is not a language that attempts to negate narration, but rather allows a narrative to be achieved without constituting its own limits. The form of language I choose to experiment with is abstract even if the motivation is always concrete.[20]

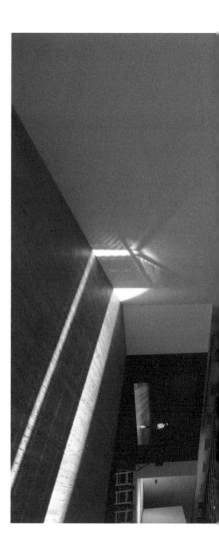

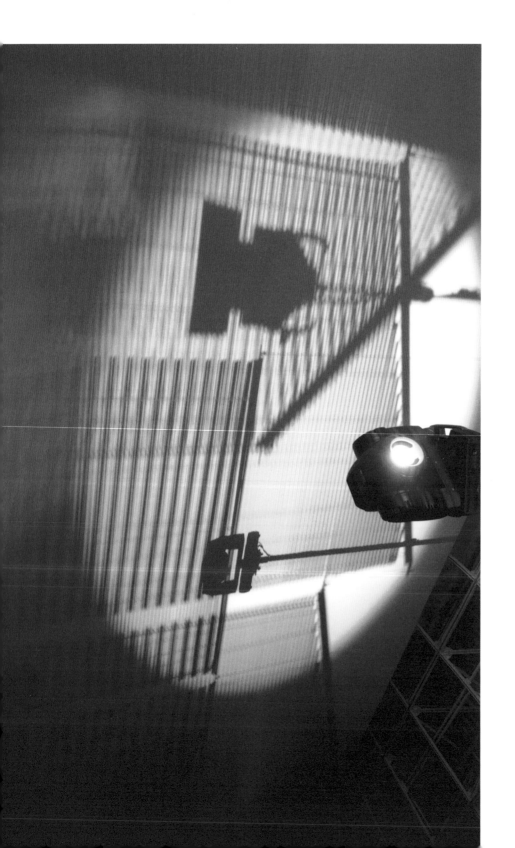

In performative terms, I am interested not only by the way that *Mountains of Encounter* alludes to this historical and political narrative through an affective theatricality that pulls viewers into an experiential realm, but also how the blinds and lights effectively embody this sensibility through what Jane Bennett would call their "vibrant materiality."[21] Though the most obviously active bodies here belong to viewers, it is not only the viewers who can be said to be active—the lights and Venetian blinds are also at work.

In 1941, Nym Wales wrote, "the intellectual is capable of action and decision only when he ceases to think in symbols instead of concrete realities."[22] Today, however, we understand that such an either/or proposition robs us of the fullness and fluid complexity present in Yang's artistic practice. In Yang's work materiality and abstract symbolism function simultaneously, intelligently enriching each other. She deftly balances modesty and monumentality, structure and porosity, and performativity and presence in her rich, inspiring work by combining immaterial ideas and material objects. Yang offers us much to think about, and to experience, simultaneously.

IV.        Performing Politics

The word "movement" can connote both
motion, and a group of individuals who share a
common ideology. This duality—a commitment
to the simultaneous activation of spatial
dimensionality and sociopolitical ideology—
is present in each of the works by Jérôme
Bel, Wu Tsang, and Haegue Yang on view in
*Double Life*, and in their practices in a broader
sense. Through various forms of re-enactment,
they offer us opportunities to arrive at
new subjective positions. Performance and
performativity are delegated to materials and
to recorded performances by actors.[23] As these
artists' works unfold through our investigation
and exploration as viewers, ideas assume a
material form. And through this action, and
our own interaction with these works, we
can come to understand the indivisibility and
simultaneity with which aesthetics and politics
operate.

1    Harold Rosenberg, "The American
     Action Painters," *Art News* 51, no. 8
     (1952): 22.
2    Social drama, according to Victor
     Turner, is comprised of four steps:
     the first is the non-normative
     action or "Breach" of social
     relations in which an individual
     or social subgroup breaks a rule,
     either intentionally or by "inward
     compulsion," in a public setting. This
     is followed by a "Crisis" during which
     the breach intensifies and presents
     itself as a challenge to normative
     social conventions. A crisis reveals
     hidden clashes of character, interest,
     and ambition. The third stage,
     "Redress," is when actions seeking
     resolution are explored. The range
     of redressive actions can be broad—
     one might receive personal advice or
     seek legal arbitration, for instance.
     Importantly though, redress unfolds
     in the public realm. Social drama's
     final phase is "Reintegration," during
     which the issues that created the
     conflict are resolved; alternately,
     if these issues are found to be
     irreparable, it is understood that
     a "Schism" has taken place. An
     accurate and concise discussion
     of social drama can be found in:
     Victor Turner, "Are there universals
     of performance in myth, ritual, and
     drama?," n.d., PDF.
3    Henry Abelove, "New York City
     Gay Liberation and the Queer
     Commuters," *Deep Gossip*
     (Minneapolis: University of
     Minnesota Press, 2003), 83.
4    I want to acknowledge my colleague
     Gregg Bordowitz for bringing
     Bishop's work to my attention,
     when, in 2006 we co-organized the
     event *This Strangest of Theaters: A
     Townhall Meeting on Politics and
     Emotion* at Roebling Hall, a gallery
     in Brooklyn. The integration of
     politics and affect in Bordowitz's
     work has been an ongoing source of
     inspiration for me.
5    Elizabeth Bishop, "Questions
     of Travel," 1965, http://www.
     poemhunter.com/poem/questions-
     of-travel/.

6   Peggy Phelan, "Welcome and Introduction. Peggy Phelan," video, 1:27:05, from *Live Culture: Performance and The Contemporary—Part 1* symposium at Tate Modern, March 29, 2003, http://www.tate.org.uk/context-comment/video/live-culture-performance-and-contemporary-part-1.

7   Within the ballroom scene, a "house" is a group of individuals who band together to form an intentional—as opposed to biological—family unit. Their composition reproduces traditional family structures, with a "mother" and "father" and adoptive "children."

8   Wu Tsang, e-mail message to the author, Dec. 9, 2014. Tsang's feedback helped to clarify that "full body quotation" establishes a sense of synchronicity through the actors' simultaneous recitation of their memorized lines.

9   Wu Tsang, "Feeling Conceptual: A Conversation Between Thomas J. Lax and Trajal Harrell, Steffani Jemison, Ralph Lemon, Okwui Okpokwasili, Wu Tsang," *Mousse*, April/May 2013, 131.

10  Ibid., 132.

11  *Full Body Quotation* was originally presented by the New Museum in New York as part of Performa 13. Though it was not presented in conjunction with *Double Life*, I have discussed it here in order to address the multiple valences that "live performance" might take.

12  Moten and Tsang created a collaborative performance that was presented as part of the series *Invito Spectatore* at Greene Exhibitions in Los Angeles on June 12, 2014.

13  Errol Morris, "Interrotron: 13 Questions and Answers on the Filmmaking of Errol Morris by Errol Morris" *FLM Magazine*, Winter 2004, http://www.errolmorris.com/content/eyecontact/interrotron.html.

14  Performances in this series include *Veronique Doisneau* (2004), *Isabel Torres* (2005), *Lutz Förster* (2009), and *Cédric Andrieux* (2009). In addition to these titles, Bel has created others—like *Xavier Le Roy* (2000) and *Pichet Klunchun and Myself* (2005)—that also consider dance and the agency of dancers. For the purpose of this essay, I will not address Bel's work *Cédric Andrieux* in-depth because of the methodological similarity it bears to another work, *Veronique Doisneau*, which is discussed here at length.

15  In conjunction with *Double Life*, presentations of *Cédric Andrieux*, Bel's eponymously titled solo for the performer, were presented on Friday, January 30 and Saturday, January 31, 2014.

16  "Performance's only life is the present. Performance cannot be saved, recorded, documented or otherwise participate in the circulation of representations of representations: once it does so, it becomes something other than performance. To the degree that performance attempts to enter the economy of reproduction, it betrays and lessens the promise of its own ontology. Performance's being, like the ontology of subjectivity proposed here, becomes itself through disappearance." Peggy Phelan, *Unmarked: The Politics of Performance* (London and New York: Routledge, 1993), 146.

17  André Lepecki, "Introduction," *Exhausting Dance: Performance and the Politics of Movement* (New York: Routledge, 2006), II.

18  "Merce Cunningham Trust: Honors and Awards," Merce Cunningham Trust website, http://www.mercecunningham.org/merce-cunningham.

19  Nym Wales (Helen Foster Snow), "Introduction," *Song of Ariran* (Cornwall, NY: Cornwall Press, 1941), xxi.

20  Haegue Yang and Clara Kim, "Haegue Yang In Conversation with Clara Kim," Wessen Geschichte: Vergangenheit in der Kunst der Gegenwart, Jahresring 56, Köln 2009, 289.

21  For an in-depth discussion of vibrant materiality, see Jane Bennett's *Vibrant Matter: A Political Ecology of Things* (Durham: Duke University Press, 2010). In her preface (p. xvi), she states: For some time political theory has acknowledged that materiality matters. But this materiality most often refers to human social structures or to the human meanings "embodied" in them and other objects. Because politics is itself often construed as an exclusively human domain, what registers on it is a set of material constraints on or a common context for human action. Dogged resistance to anthropocentrism is perhaps the main difference between the vital materialism I pursue and this kind of historical materialism. I will emphasize, even overemphasize, the agentic contributions of nonhuman forces (operating in human nature, the human body, and in human artifacts) in an attempt to counter the narcissistic reflex of human language and thought. We need to cultivate a bit of anthropomorphism—the idea that human agency has some echoes in nonhuman nature—to counter the narcissism of humans in charge of the world.

22  Nym Wales, xxiv.

23  I am indebted to my colleague Max Fields for his recognition of the notion of "delegated performance."

Your    Heart

is

a

Strong Muscle,

It    Squeezes

Very    Good

Litia Perta

*I guess what I'm trying to say
is that, at a certain point, what
one comes to grips with—and
what I think we all need to
come to grips with continually
(because it's very, very easy
to forget)—is that the kinds of
stuff that we actually want to
do, I mean the kinds of things
that I think we all desire, are
the kinds of things that you
cannot do by yourself. So that,
what's at stake, precisely, is
the irreducible necessity of
collectivity.*

—Fred Moten[1]

Yes.

                                                                          Yes.

Are you there?

                                                                 Are you there?

Yes.

                                                                          Yes.

Are you reading me?

                                                          Are you reading me?

Yes.

                                                                          Yes.

And do you like what it is you read?

                                           And do you like what it is you read?

I am sitting at my lover's desk. The desert stretches out before me, mountains in the distance. One voice comes through my left ear, the other through my right and together they are a honeyed cacophony of syllables and sounds, mixed responses and missed questions, the swallowed giggle of self-conscious laughter, the kind that happens when you are mostly laughing at yourself. There is shyness to them both, as if they know they will be listened to but not exactly when they speak. And their voices are low toned, as if speaking very closely but not (quite) to one another. One voice comes, a kind of polished, smoothly out, originating in the throat, propelled by breath from further down, stomach muscles taut, holding. The other voice comes from a low down place, maybe this world maybe not, and the belly of its timbre is so broad you could lean right into it and it would hammock you— the kind of voice that makes you want to fall, in. The voices speak and they are two but they do not talk to one another, not exactly, and they are not talking to themselves, not quite. You could stay here for a long time.
I (is) am somewhere in between.
We are listeners.
Listen in.

I am in the darkest room. My arms keep reaching out before me to feel their way along the black but I snap them down each time, embarrassed in advance, in case other people's eyes can somehow see me in this light. She arrests me long before I let her take me in (I see her right away). She is cut off at the belly, her light pink white figure held suspended inside a field of fur-like black. She is so erect that as she stalks across the stage, her body is a backslash, a punctuation point for every patch of ground she passes over. She walks slowly, measured, and when she reaches front and center, she stands, tutu-tulle beneath one arm, a bottle of water in the other, breathing. She surveys the scene, gauges. A tiny tug of eyes, squint, she is watching them as they are watching her and she is watching them, pause, gaze. Very slowly, her voice climbs a ladder like a question, *Je m'appelle*, hangs there, and then descends into the name, *Veronique Doisneau*. You could stay here for a long time.
I (is) am somewhere in between.
We are watchers.
Watching.

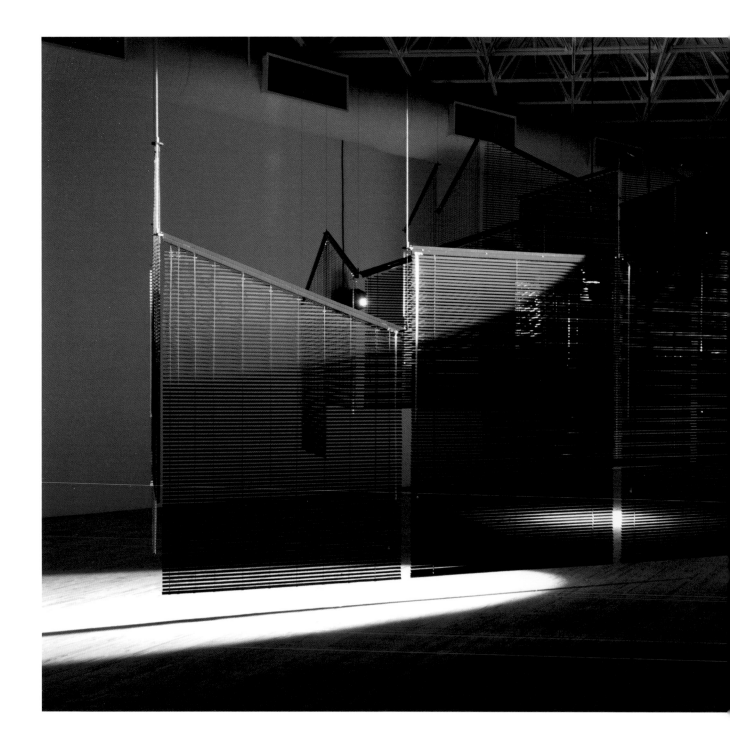

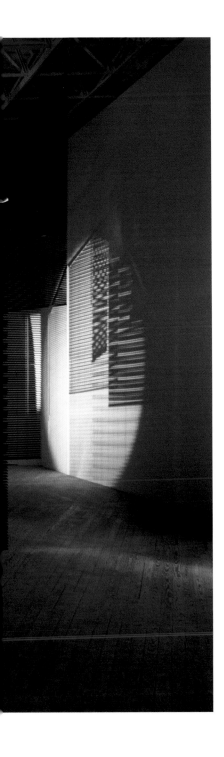

You come to know her work through a 13-inch rectangular computer screen. You see everything you can before you settle into Red. You think constantly of blinds—the kind that block the light out from the windows, the kind that block peripheries of sight, the kind that snatches sight away from someone, something—you are thinking of these always. You remember all the myths when loss of sight makes way for vision. You check out *The Song of Ariran* from the library and read it bit by bit. All this time, the hissing sound metallic blinds make when they are raised or lowered against the sun, against the night— the whistling scintillation when they are worried by a breeze—this is the sound that haunts you. You follow the peaks and ridges of the red, you follow the perfect circles of the light, spots, you think of searchlights roaming craggy mountains, you think of spotlights grazing titty-tassels. You wonder what it means to illuminate, to know, and you remember the darkness that illumination, knowledge, depends upon to be.
You could be here for a long while.
And so you are.
And so *you*,
are.

is the last performance she will ever give at the Paris Opera house. She goes on to explain that although she has danced her whole life, she never became a "star," that it was never a question. She says simply, "I think I was not talented enough." As the piece proceeds, what we are given to see is both the story of a dancer's life and also the ways that life would usually remain invisible to us because she has not attained the celebrity that would render her offstage life of interest. Despite Doisneau being on the stage for the better part of a lifetime—that is, despite her body's hyper-visibility as a performer—her relations, her preferences, her joys, all this would generally remain invisible, unknown. The telling of her story makes visible both her own dimensionality as well as the deep erasure of the countless many other stories just like hers that we will not know because of the ways we (do not) see.

Performance has the power to reveal lacunae in our ways of seeing. As in the case of Bel's work, it can open up complicated critiques of the ways we see or don't see, of the kinds of beings we do or don't privilege, and of the ways in which these assumptions and presumptions are inextricable from how we see ourselves. If you look up the word "performance" in the dictionary, you will find a long list of definitions, many of which diverge from one another, depending on their contexts. The two primary senses are that of

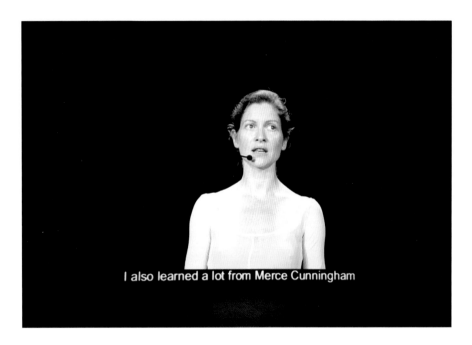

I also learned a lot from Merce Cunningham

In Jérôme Bel's 2004 video piece *Veronique Doisneau*, named for the performer it features, we see a woman emerge onto an empty stage before a packed Parisian audience. She wears a pink leotard beneath black stretch pants and a light pink coverlet. She looks as though she might be attending a ballet class or a dance rehearsal. She has white skin, light brown hair, a strong brow and intelligent eyes. There is nothing costume-like about what she wears; her hair is loosely pulled back from her face and she wears no makeup. A tiny microphone protrudes from her ear, making a short dash of black near her mouth to pick up her voice, her breathing. She says plainly, her name is Veronique Doisneau and proceeds to give an account of herself. She is 42, she will retire in eight days, and this

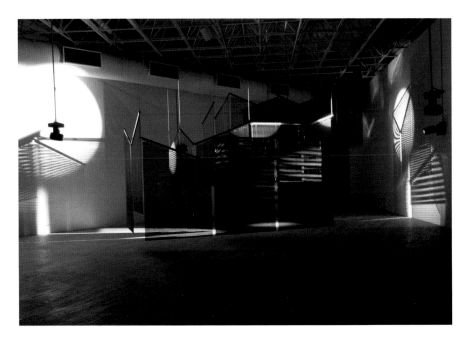

staging an action—a play or some other composition—and the more general sense of the doing or carrying out of a task or of a function. What both of these point to is the way in which human being has extension: we are bodies that extend into space, and so our being is inevitably bound up with a kind of perceptibility. We are available to be perceived. We can be seen.

The works called together in *Double Life* move the way performance moves, they ask us to rethink what performance is, what it can be, and what can count as "it." They tell us something about how our seeing works: what contributes to that sight, what makes it possible and also, what elements take the possibility of it away. They ask us to consider the ways that we respond to objects, video and sound in a manner much like how we respond to beings. Similarly, they urge us to consider the ways in which objects might also be responding—asking us to consider the response-ability of objects, the possibility of answering-machines. This is not simple poetics. (Poetics are never simple.) This allows us to critically consider the ways in which some people are granted human status while others are refused it.[2] A series of questions opens up that investigates the ways being human is contingent upon perceptibility and perceptibility, in turn, depends upon relation. The ability to be perceived is not a given. It is contingent on the ways we do or do not conform to the normative structures that

confer on us the ability to be recognized. As Judith Butler writes of the particular structure of gender, our movements in it are "a practice of improvisation within a scene of constraint."[3] We are all players playing to a public and at the same time, we are that public. Being seems to happen in between.

It is no accident that Butler's language draws on the vocabularies of theater ("improvisation," "scene"). What she is moving toward are the complex set of relations that are constantly happening in performance, and so are constantly happening in being. While performance is often framed as oppositional to something like authenticity, (human) being is itself bound up with performance, is always performing, is always performing to be recognized.[4] In resisting the notion of an authentic, singular self, being-as-performance stands to tell us something about what it means to be and about what it means to be always already in relation, to be always already players dependent upon others who are also playing. This is the proposition of *Double Life*. These works ask us to rethink notions of performer and viewer, actor and audience, self and other, upsetting binary relations so that we might rethink them, re-feel them. They coax us toward a multiple kind of being, a kind of being-multiple that has to do with difference and with resisting the normative structures that would limit that difference. They coax us toward seeing (being) in between.

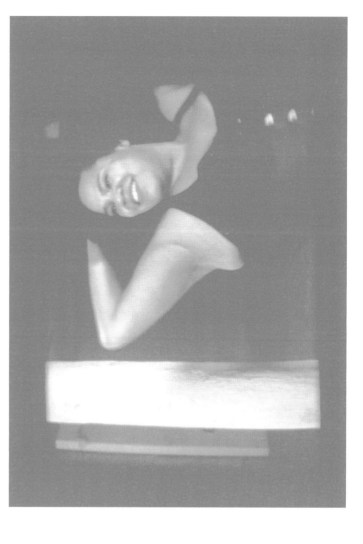

Wu Tsang's 2012 work *For how we perceived a life (Take 3)* unsettles. Shot on a single roll of 16mm film, the piece plays in a loop over and over again, disrupting conventional notions of linear time, what we expect of film and what we expect of performances—their beginnings and their ends. In a night-lit loft space, five bodies enact a series of movements, gestures, and scenes that slip over one another in sound while the players blur the spaces between one another with their bodies. Interchanging lines and switching perspectives without warning, the ensemble unsettles dominant narratives about race by allowing the players to slip in and out of markers and designations fluidly and often, irrespective of appearance. This fluidity also unsettles conventional notions of gender as the players move through different positionalities, upsetting the traditional importance placed on presentation by marking themselves through gesture

and speech, linking gender inextricably to performance. Traditional authorship is complicated by Tsang's having culled dialogue in part from the archival material related to Jennie Livingston's documentary film *Paris is Burning* (1990), injecting further question and critique into the already complicated debate around ownership of words and the authorial role of the filmmaker. The players lip-synch to a prerecorded soundtrack of their own voices so there is a subtle discrepancy between what we hear and what we see, disrupting the seamlessness of the work as a whole, and asking us to consider the break between performance and being, unsettling any facile distinction between the two.

Following the break in the film that signals the loop has begun again, a shaky camera steadies as the transitional sound echoes into silky quiet. A voice emerges, hot and close, as if the mouth that made it hovered just above the microphone

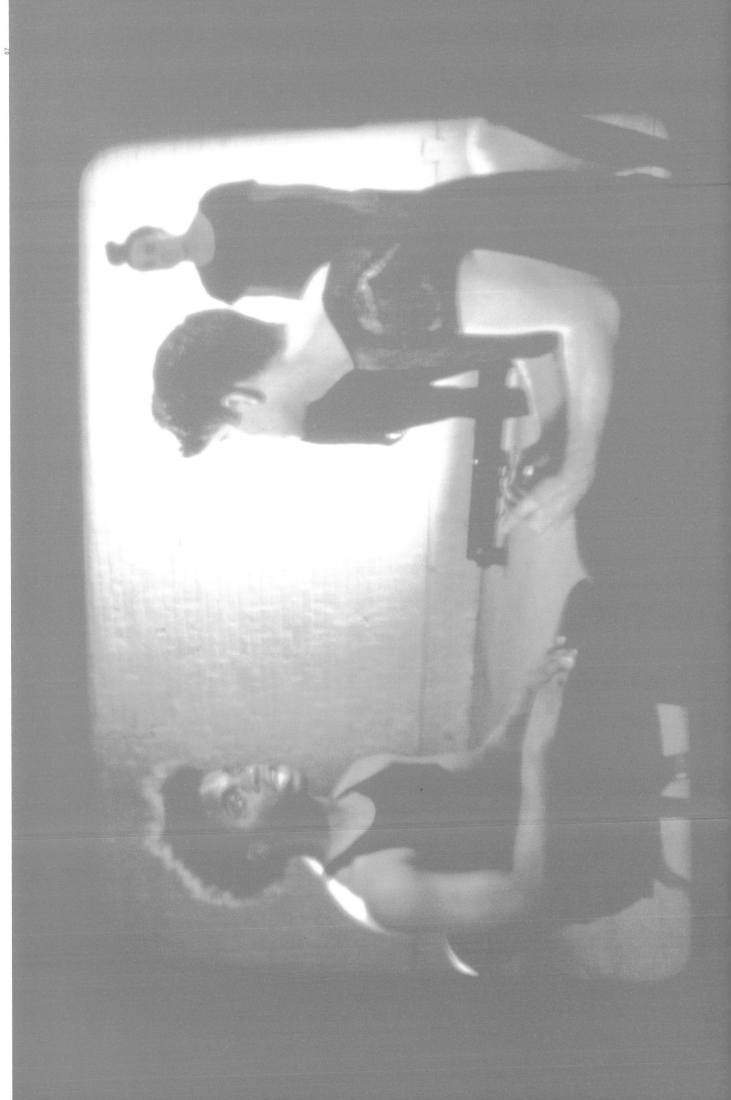

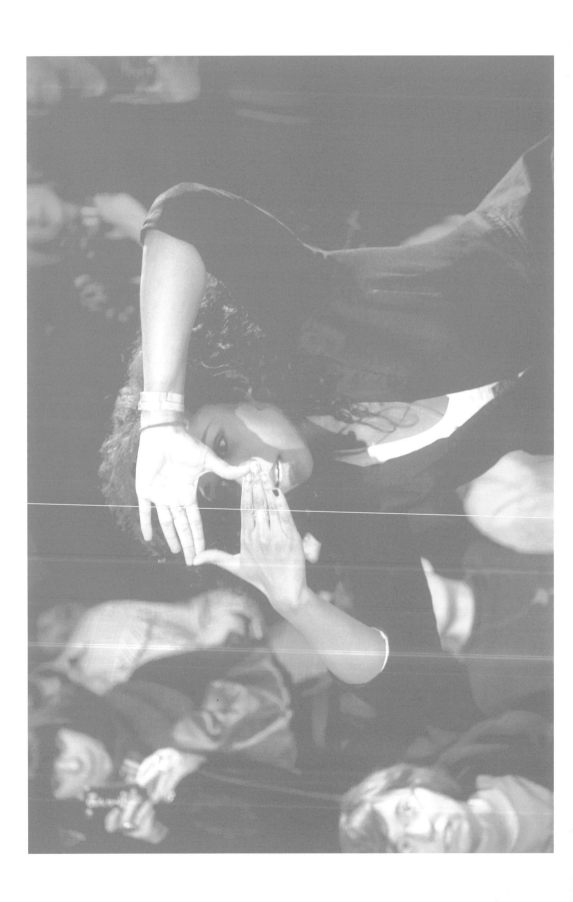

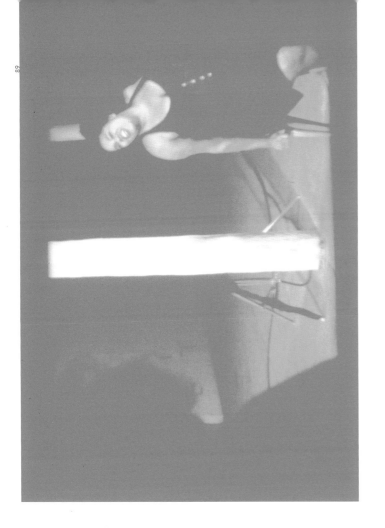

that picked it up: "I believe that there's a big future out there, a lotta beautiful things, lotta handsome men..." The camera moves us, handheld, deeper into a loft space with a long wall of painted white brick running down one side, ending in a large window where a city night shows through from outside, lights a-sheen. Two banks of bright footlights rest on the concrete floor, shining lantern-like shapes on the bricks a foot away. In the dim space on the other side of the footlights, unlit, a huddle of bodies: we can make out two feet, maybe naked arms, a head, but no distinction—they are a mass, together, and they move that way, writhing. "I want a car," another voice breathes, slow and bedroom, desire-laden. These voices are not mapped onto particular bodies: it is not possible to tether voice to form, desire to (a) self. They are not mapped onto particular genders either: each one sounding as if it could be a

woman's voice pitched lower like a man's or a man's voice, breathy, pitched higher like a woman's—rendering the categories, these binaries, slippery and suspect. The voices and the huddle that seems to be their origin-point present a range of possibilities, opening up a spectrum of femininity-masculinity, a spectrum of possible selves doing the desiring.

As the camera moves closer to the huddle, we begin to have a sense of the shapes of the bodies that make it up. All are clad in black and remain tangled together, sliding limbs in and out slowly, so that the mass of them looks like a single organism, breathing. Collective, whole: the people as a body. They continue to articulate their desires, each of which originates from a spoken "I." But this "I" is neither singular nor fixed, instead sliding interchangeably

between and among bodies, marking
the fluidities among them rather than
observing the policing of borders that
so often works to keep us separate,
distinct. Although everything about
this being, these beings, resists
normative formulations of selfhood
and singularity, the desires the voices
articulate adhere almost entirely to
markers of normative success, to the
possibility of being recognized within
these frames. What is desired is to be
married in church in white, to appear
in magazines, to be a professional
model, and to complete a sex change,
realizing possibility in these desires.
Here the piece opens up an inter-

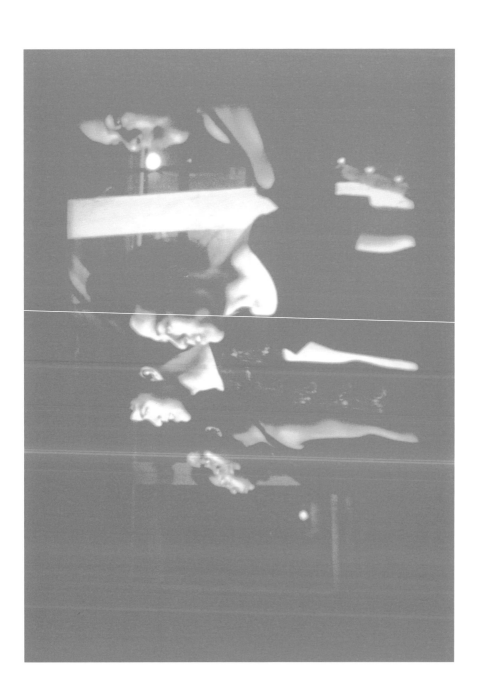

implied space of critique—in which the violence of the strict confines of normativity is perceptible at the same time as normativity itself is shown to be subvert-able, less strict or confined than it may at first at seem. Simultaneously, these players inhabit the roles they play so seamlessly, so completely—every gesture, every nuance of voice, pitch—calls to mind the faces in Livingston's *Paris is Burning*. And so here too there is a kind of being double: being at once the player playing as well as hearkening back to the person played. The huddle of bodies disperses to each play multiple characters, to swap and slide among and between the roles they enter without warning, without rupture, again breathing and seeming almost as one and also always multiple. A version of the work has also been staged live under the title of *Full Body Quotation*, a term that (among other things) indicates the level of practice and study that the adoption of these voices and gestures require. This theatricality, the ability to fully come inside the body, the breathing, the movement, of another, allows the players to exercise a kind of being that is neither singular nor stationary. Each of them refuses to take up or hold just one place, just one position. Within this system of relations, our own position is allowed to proliferate, inviting us to consider being as always already (at least) double.

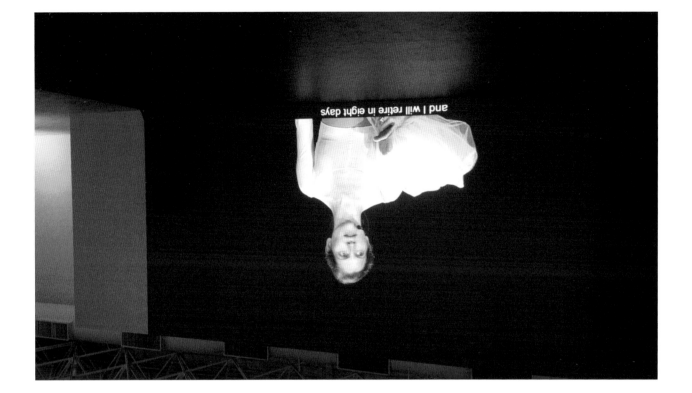

and I will retire in eight days

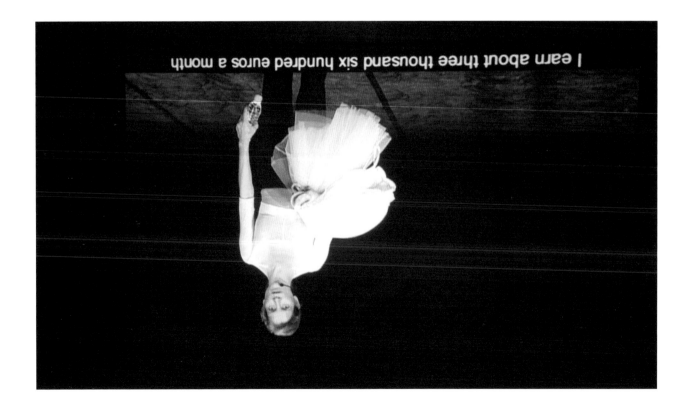

I earn about three thousand six hundred euros a month

If the kind of doubling or proliferation we are given to see in *For how we perceived a life (Take 3)* is one that hinges on theatricality, on inhabiting multiple positionalities in such a way that each reveals itself to be fluid, relational, not *one*—then the kind of proliferation we are given to see through Jérôme Bel's *Veronique Doisneau* has something more to do with a theater of the authentic. In this piece, Veronique Doisneau recounts her inner workings, her interior experiences— the kinds of stories and information we would never usually get from an ensemble dancer. The result of revealing what is traditionally occluded or erased is manifold. We are given to see the limits of our own sight, the ways in which spectacle corrals the attention to focus it only on what it wants us to notice and follow, thereby occluding the beings, the lives of the people who make it up. And we are given to see that being is always more complicated, more proliferate, than we imagine. As Doisneau reveals (one could say here, by way of reminder, as she *performs*) her own interiority, we are given a kind of retroactive insight into what happens in a dancer's psyche while the audience is paying attention to her body. The hyper-visibility of her form and her movement carries with it the inevitable invisibility of her other realms, the other ways in which she is/experiences being. This tells us something about spectacle but it also

tells us something about the way being works within the theater of the real.

A few minutes into Bel's work, Doisneau sets down the props she has brought out onto the stage with her—the tulle-tutu, her ballet slippers, and a bottle of water. She does this in order to illustrate a passage of dance that she says she loves. She walks back to the corner of the bare stage. No light follows her. And then she turns around, pauses, and begins to dance. No music accompanies her movement so she hums the tune herself, tapping it out with her tongue, her lips. Surprisingly quickly, her humming becomes more breath than sound as the microphone she wears at her mouth amplifies the effort of her movements. In this moment, we realize that we are accustomed to seeing this kind of physical exertion (for someone untrained in ballet, her movements do not seem extraordinarily challenging) but we are totally unaccustomed to *hearing* its effects. Bel's work is fascinating in part because he has chosen to showcase ballet, a form of dance that works strenuously to erase all traces of effort, all evidence of a body's limitations or strain, foregoing process for product. As Doisneau comes to the end of the dance passage, she lets go her poise, places her hands on her hips, lets her shoulders cave in and turns away from the audience, allowing the percussive rhythm of her

breath to fill the theater. After some moments of this, she turns back towards the audience, places her hands on her knees, bending over, showing us the time it takes to recover from just a few moments of dance. She does not hurry. Throughout the piece, her movements have a kind of defiance in them, as if after a career of hiding the effort required to do what she does, she is through with masking and now takes all the time that she needs to catch her breath, to change her shoes. A frequent furrow haunts her brow, there is an encroaching downturn to the edges of her mouth, and she often looks out into the darkness of the theater with a kind of challenge on her face, as if taunting us with what we have so long left unknown, erased: the *her* of her.

Approaching the end of Bel's piece, Doisneau puts forth that one of the most beautiful moments in classical ballet is, "the scene from *Swan Lake* where 32 female dancers of the *corps de ballet* dance together." Her face shines as she says this, as if for a moment she can see and appreciate this dance the way an audience member might. "But," she continues, "in this scene there are long moments of immobility...we become human decor to highlight the stars. And for us, it is the most horrible thing we do." Her face seems filled with rancor: the most beautiful thing for the audience to watch is also

performer's experience to focus on what is highlighted, so too with the people in our lives. If performance is one of the primary modalities of being—if, indeed, in order to be, I must perform myself and be recognized, received by others, then my being extends somewhere in the gauzy space between performance and recognition, between self and other—living, breathing—somewhere in between.

This sense of extending ourselves out over the precipitous risk that is the attention of, the need for recognition from, the other is part of what lends itself to the feeling of melancholy that haunts *Veronique Doisneau*. In the beginning, she looks out over the audience and we are able to see what she sees: a crowd in darkness, breathing but invisible. She looks to the highest reaches of the balcony to advise those that are too far to see her that she is often told she looks like the French actress Isabelle Huppert. People

laugh. But the camera gives us to see, just for a moment, what those in the balcony are seeing, and it is precious little—they must be barely making out the figure standing there. This fact of the piece is equally a condition of being: that our messages, our extension outward, need not garner response. Indeed, response-ability is contingent, which means it has the possibility not to be.[5] In this way, *Veronique Doisneau* tells us something about spectacle as well as something about the real.

Doisneau may perhaps take the train home from the opera house, as she may have done countless times before. She will go to the husband she speaks of, and to her sleeping children, to the sounds of their breath. And—other than the intuitive feeling that she has been heard—she may not know, she may not ever know, the impact she has had, the ways in which she is (still) teaching us to see.

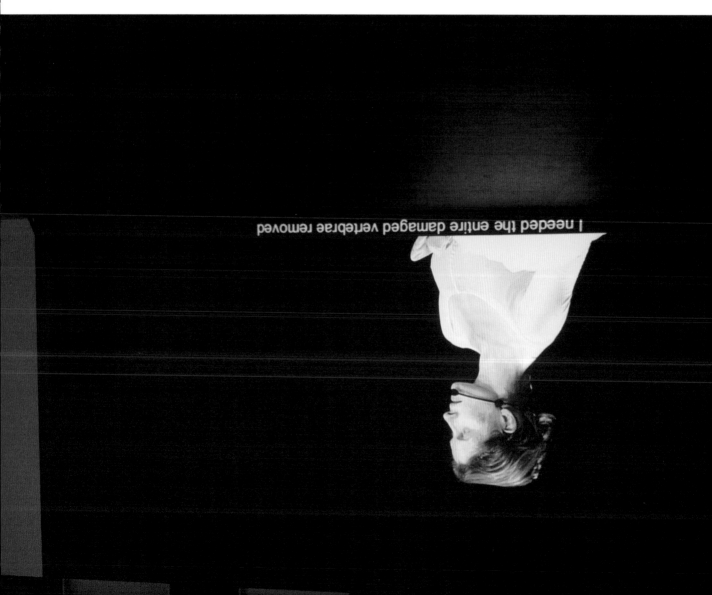

I needed the entire damaged vertebrae removed

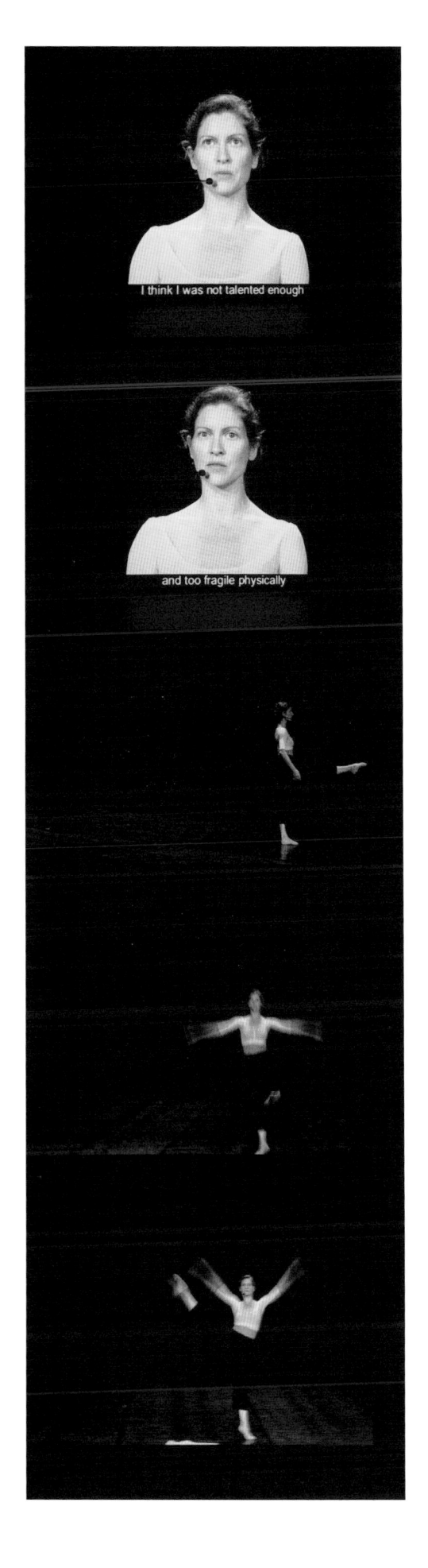

I think I was not talented enough

and too fragile physically

the most hated thing for the dancers to do. This is the cost of spectacle, of not allowing for multiplicities when witnessing the work of others, particularly works that call upon the presence of the body, work in which being is made to be singularly physical. The piece turns this tendency back on the audience, a form of critique that allows us to see what we have not been seeing. Doisneau proceeds to illustrate the very thing she most detests, the thing that makes her "want to scream, or even leave the stage." For the first time in the video, she requests music to accompany her illustration so that she is able to render the long passages of stillness she so detests. In over eight minutes of music, she holds barely three poses—two of which require her to keep her arms high, outstretched— with only a smattering of small steps in between. This illustration showcases what is never showcased, foregrounds this figure designed to remain in the background and go unnoticed as "human decor." And so *Veronique Doisneau* mounts an act of resistance, challenging us to see better and more fully, challenging us to not allow our vision to funnel being into an only-ever-one-thing, into the confines of singularity.

Something more than a critique of spectatorship arises throughout Bel's piece: there is also a critique of just this notion of singular being. By showing us the inner workings of a dancer as she moves through her craft, by giving us to see the way she wants to scream when holding the "poses" in *Swan Lake* for so long, we are given to see the (always at least) doubled life of spectacle. For every body rendered visible, *Veronique Doisneau* cautions us to remember that vast realms are being occluded at the very same time. Appearance and disappearance are interlinked. Although the frame of the work is spectacle, the critique of the way we see the world and other beings in it translates into more quotidian frames. Just as we siphon out a

Haegue Yang's *Mountains of Encounter* (2008) does not open up performance through human being but does so instead through the response-ability of objects, by asking viewers to move through a field of things, sensing and noticing the ways in which that field may answer back. The piece is comprised of a series of custom-made Venetian blinds, hung from the ceiling and clustered together to look much like the top of a mountain range or like a scar coming into bloom. The blinds are a bright poppy-red and large size circles of light—spots—rove over them at hypnotic speeds, tracing out infinity loops with occasional digressions as they go. Yang's work was directly inspired by the story of a Korean national named Jang Jirak and an American journalist who wrote of him and perhaps also fell in love with him—a woman by the name of Helen Foster Snow. Under the pen name Nym Wales, Snow wrote and published a book called *Song of Ariran* (1941) for which she drew primarily from secret interviews she conducted with Jirak (whom she calls Kim San in her book), a freedom fighter working to resist Japanese imperialism in Korea. Perhaps most noteworthy in their communion is what Behm describes on Haegue Yang's website as the "existence and extraordinary life of the outsider Kim San... conveyed from the perspective of another outsider."[6] These two figures exemplify the ways in which certain encounters we have can make mountains in the topography of one's life: we are altered by them, we seek refuge in them. And perhaps most importantly, these beings that most figure in *Mountains of Encounter* are beings that shared a sense, culturally and socially, of being outside.

If being can be said to be a kind of performance wherein I am (always already) called to be for a listener, seer, receiver who is (always already) there listening, then what does it mean to be outside? Who gets to be outside this movement and who *has* to be, is required to be—and what is the difference? What does it mean to be asked to encounter these blinds, this structure that looks like a mountain range or a mechanical blossom, and be quietly invited to move through

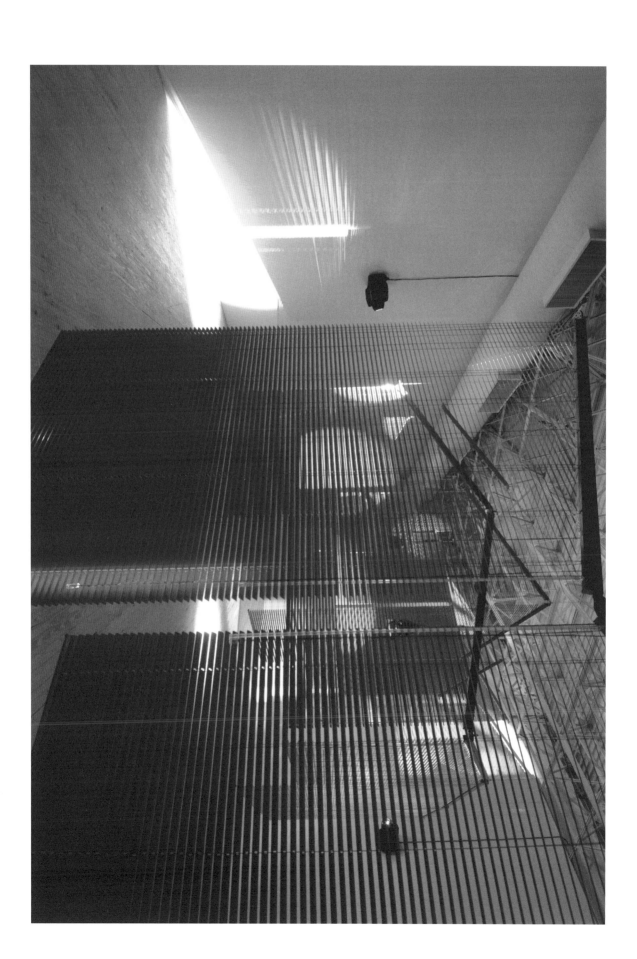

or rethinking performance as primary to being, allows for that striation to be at once only ever a part of the picture as well as its own complete picture of sorts. In *Mountains of Encounter*, what we are often given to see through the blinds is no outside at all, but other blinds: seeing blinds through blinds through blinds: seeing these red ones are hung as a constellation, a network both angled and adjoined. Performance here offers up a similar logic: thinking about performance-as-being, beyond a particular performance is often another performance, and another, and so on: a kind of variegated landscape of showing and disappearing. The idea is not that with enough searching one might find an origin point, some ground for authenticity. Instead, the work is to allow being itself to proliferate, to refuse it the singularity so often imposed on it—to let it be multiple, striated, strange.

Watching the lights rove around the network of blinds, it becomes clear that these searching lights speak also to the ways we tend to see. Peering through the slatted striations, the mind fills in the picture of what it sees, assuming what is there even (perhaps especially) when it can not see fully at all. We cast the things we cannot see in certain light—perhaps more accurately in certain darkness—imagining we know them or judging them to be unknowable. This movement of seeing through blinds is another way in which Yang's work critiques a kind of sight that assumes what it does not see, or else renders invisible what it can not envision. This is the way we render others outside. In the face of a being I can not see fully, I either assume the parts I can not see, or I pronounce the being's nature impossible to see, unknowable, not available to be recognized, thus rendering a human

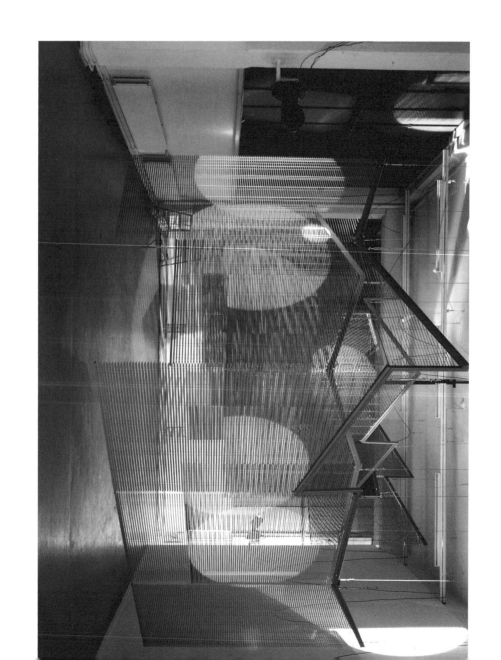

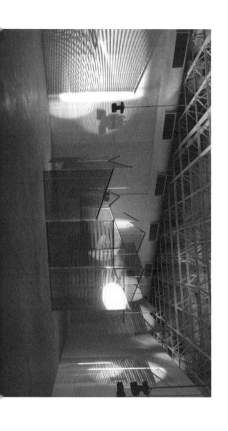

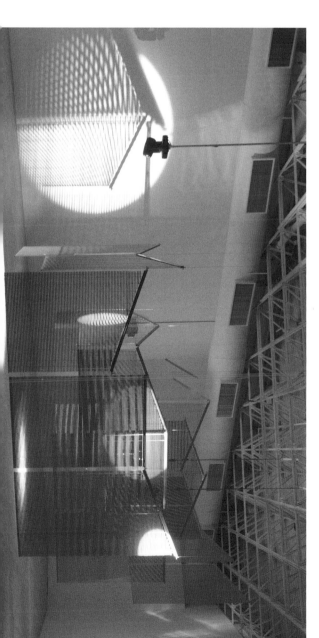

it, to be with it, to see one's self being with it as a set of inanimate objects that should not be breathing but seem to respond to me nonetheless?

The poppy-red blinds are similar sizes to the ones usually found shading the light from windows. But when they are pieced together side-by-side, they form an enormous constellation that literally engulfs space. They are placed in front of one another at labyrinthine angles, so that what one sees when wandering around or through the work are striated versions of the real, slatted glimpses of what is there but no pretense of a complete picture.

In this way, Mountains of Encounter offers its own critique of human sight, of recognition and reception of the other. In addition, it offers a proposition towards being—a sense that we are always more than what we see, and that what we see is always only a sliver of what we are.

Yang's critique of human sight or of vision renders wholeness impossible, a fantasy, because what one sees—the partial image that so often becomes a whole—is in reality more like slatted striations, glimpses of and snatches between. We are only given to see parts at a time. Being as performance,

He goes on to ask us to consider instead what if we were to "Agree not merely to the right to difference but, carrying this further, agree also to the right to opacity...."?[8] Because, he writes, "Opacities can coexist and converge, weaving fabrics. To understand these truly one must focus on the texture of the weave and not on the nature of its components."[9] To focus on the texture of the weave is to bear witness to what is before you, to attune to (only) that which is directly before you. To focus on the texture of the weave would be like focusing on, allowing for, the striation of the blinds: what they do tell us, and all they ask us to allow to remain untold. To

focus on the texture of the weave without extrapolating out to presume the nature of (the totality of, the wholeness or the essence of) the weave's components, is like saying "yes" to this slatted version of reality, to not presuming or filling in the parts we cannot see.

In a 2012 interview for the Tate about a piece that also uses Venetian blinds, Yang explains that what she most desires to produce with the work "is that you feel disconnected."[10] The elements through which one usually connects: unobstructed sight, sound, a presumed transparency of meaning are, in Yang's work, disabled, disoriented, obstructed. In spatial form,

Yang proposes a similar thought experiment to the one Glissant engages: the possibility that non-understanding, non-transparency, might be the basis for ethics, for a kind of regard for the other precisely because you do not know her, because you can not see. Yang's work mines the condition of the outlier, the alien, the jettisoned. In an older interview for the Carnegie International, she says, "any place which is—" and here she stops to correct herself, any place which, "sounds—unfamiliar or uncanny seems to me very familiar..."[11] Her correction is important: she will not essentialize or speak to the nature of a place by asserting that it

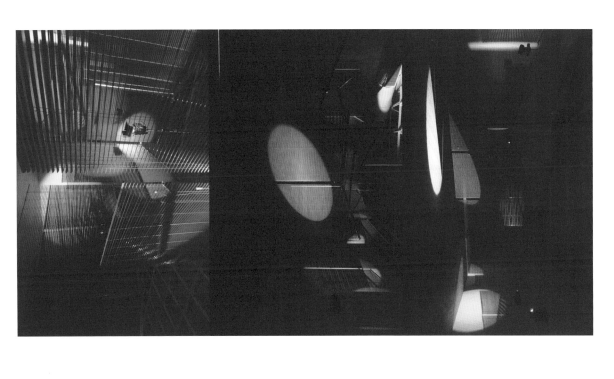

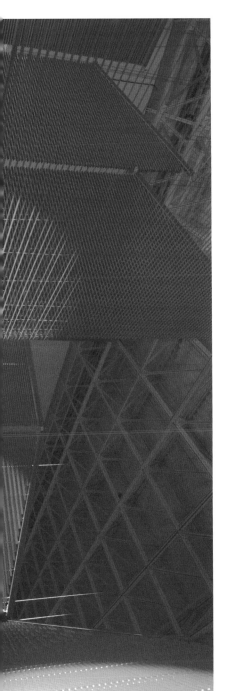

being other than human, other than being—outside. If our interaction with
the network of blinds is reminiscent of our interaction with the performance,
the appearance, of others, then the piece shows us the ways in which we tend
to make up or assume the things we cannot see. Here too, Yang offers up a
critique of sight that opens up questions of ethics: How do we stand before
the other? How do we see and how do we receive? In what ways might it be
possible to come before the other and not assume, not presume to know?

In his book *Poetics of Relation*, Martinican poet and philosopher Édouard
Glissant, speaks to the possibility of an ethics arising not from knowing the
other but precisely from an acknowledgment of non-knowing. We cannot see
fully through the blinds. In a chapter he calls "For Opacity," he postulates
claiming the rights not only to difference but also to opacity, to non-
transparency, the right to being not see-through-able, not assumed to be able
to be seen (through). Ethics, he puts forward, might start from here—from an
acknowledgment of non-knowing. He writes:

> If we examine the process of "understanding" people
> and ideas from the perspective of Western thought, we
> discover that its basis is this requirement for transparency.
> In order to understand and thus accept you, I have to
> measure your solidity with the ideal scale providing
> me with grounds to make comparisons and, perhaps,
> judgments. I have to reduce.[7]

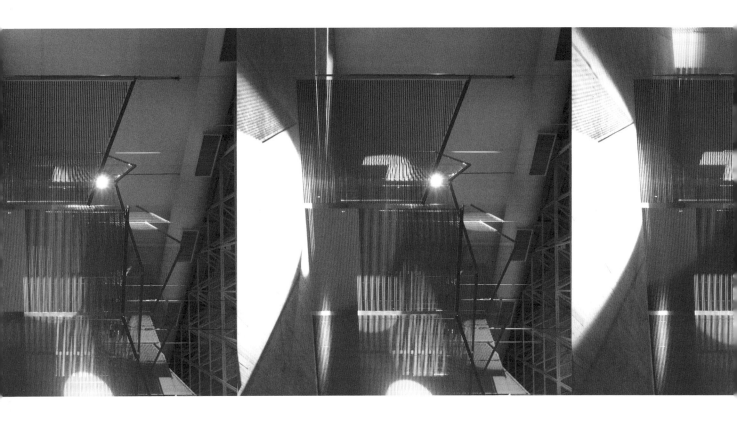

*is* unfamiliar or uncanny. Instead she reminds us of performance and amends: some place, some thing that might sound unfamiliar, seem unfamiliar, leaving room for it not to be. And then she tells us that these are the exact places in which she finds herself most at home.

The composition of the interview video bears mention. In it, the artist appears with short black hair and a black suit on in the middle of a stark white field. This removes her from a context that is anything other than whiteness, and makes her the only and inevitable foreground or focal point in what seems like an effort toward just the kind of transparency Glissant critiques. One thing that interests me here is the fact that the questions posed have been edited out, so Yang is shown sitting alone, clearly looking carefully at a person who is before her but whose voice and image have been erased. And so she speaks, opens, with no clear or certain sign of response. Like in *Veronique Doisneau*, there is a sense of missing here, a lag time or disjoint between the speaker and the one who responds that opens up questions around communication and the possibilities of connection. In an effort to generate a sense of timelessness, Yang's real-time interlocutor has been edited out, casting doubt on the possibilities of response-ability in real time, leaving us like listeners to a series of messages, wondering what exactly happens in between.

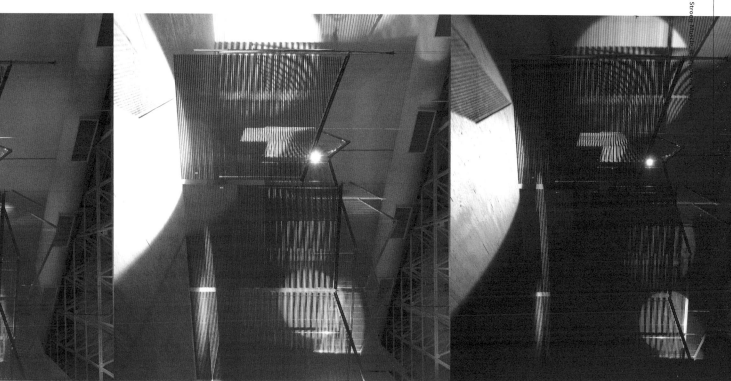

The work that completes the proposition that is and will be *Double Life* is the premiere of Wu Tsang's *Miss Communication and Mr:Re* (2014), a two-channel video installation made in collaboration with the poet and scholar Fred Moten. For the piece, Tsang and Moten agreed to call each other every day at 9am over the course of a two-week period during the summer of 2014. Each one hailed from a different time zone and had agreed not to pick up the call but to instead leave messages for one another. This raw material was then jointly, mutually, edited. Tsang made selections from Moten's messages and Moten made selections from Tsang's. These were crafted into a sound track for a two channel video installation. The video records each of them, framed separately in black, able to be placed side by side or opposite one another. They look directly into the camera and so directly out at us. We never see either one speak, although their mingled voices tap, trip, sigh, constantly along in sound as we watch their faces seeming to watch us. They shift from suppressing laughter to expressing something that looks like deep love, to longing, to seeming to well up with tears, to no legible expression at all.

Although they do not speak, between the intimate trotting of their voices and the intensities of their gaze, we seem to *see* them, to know them, and we see them seeing, knowing, each other. We hear each voice call out to the other from a place of solitude: around them mostly silence. And each one calls out, searching toward togetherness, towards being (mutually) heard. At the same time, their work is made available for an audience, for us, to hear them hearing one another. Even as each voice, each image, remains on a separate channel, their words speak to one another, call out, respond, mingle. Sometimes they sync up to say the same words at the same time; and their faces seem almost as if they are seeing one another, gazing into one another's eyes as they seem to gaze into our own. The piece raises questions about the structure of communication as well as the possibilities of meeting

someone, of connecting with them. It opens up the space/time of the telephonic, a space/time in which a call is made and a response is given or, as in this case, a message is left as a form of response, to be subsequently received. The delay between the leaving of a message and its being heard—as well as the possibility that the message will not be heard at all—opens up questions of sociality and connection. Where are our messages while they are not being heard? And what kind of being is this that extends into and through a gauzy network of calls, answers, responses—the voices that we are and the ones that we listen for?

Towards the beginning of the piece Moten's voice raises the idea of the message itself. Both faces stare tenderly into the lens of the camera. They seem somehow to be able to see us, the viewer they can't possibly see is there, at the same time as it seems as if they must be able to also see each other—despite the fact that the video can place them side-by-side, technically unable to meet eyes. Tsang's voice on the left channel moves through pieces of a story—we hear him say "hate crime" and then, with more careful listening, he confesses to losing clarity around how it's possible to know someone, to know their struggle, and then also at the same time, to "have no idea"—the worry of unknowability setting in. While this is happening, Moten slowly, carefully, wonders if:

> *...every time anybody touched anything what they were also always doing was sending a message back somewhere... that what it means to walk, you know, through the air, to brush up against atoms, to brush up against molecules... think maybe it's all just sending a message, think we're walking through an atmosphere of messages.*
> *maybe.*
> *don't know...*
> *just...just blurring.*[12]

In the moment that one voice articulates the existential worry that arises from not being able to be sure we (can) really know another being, the other voice describes an existence that is full of messages, messaging, one in which we are inter-written, through and through, with signals and sendings between others and ourselves—indeed, maybe so much so that the boundaries between other and self blur or were always already (a) blur. Moten asks us to imagine that, in the same way that we brush up against atoms and molecules simply by moving through the air, simply by walking, so too it might be with messages. Perhaps we are constantly brushing up against them, perhaps being is necessarily porous to them because they are literally atmospheric. This leaves being intrinsically open to being crossed into or touched, open to being multiple, together, constantly receiving messages and sending them, an almost involuntary calling toward and answering to. So this network of voices and information leaves being—"my" being or "your" being—as actually something that is interwoven, something that spans the space between us—being as a place that both is and marks the call.

What is a message, exactly? Formal definition places it as a recorded communication sent to or left out for someone who cannot be reached directly. What does it mean to leave a message for someone? What does it mean for a being to not be able to be reached directly? What if this condition spoke less to something situational in a person's life and more to something intrinsic to being itself, something more about what it means to *be*? The word "message" comes to us from the Latin root for the word that means "*to send*." In an older etymological dictionary, one that works with the root syllables of words, I find embedded in message's meaning a word that means "to throw."[13] The example given is to throw dung on a wall to dry it and use it for fuel. There is hurling here, flinging, a thrown-ness—marking being as a kind of emission, a throwing out (a being thrown) into a span. This being has agency while at the same time it depends upon a pre-existing network of voices, messages, other agents, in order to be recognized, in order to be. This is Fred Moten's "irreducible necessity of collectivity." It has to do with being, and with being always and inevitably between.

Thirty years ago, when I was only seven, Jacques Derrida delivered the opening address at the Ninth International James Joyce Symposium in Frankfurt, Germany. During his address, among many other things, he describes the central character of James Joyce's *Ulysses* as a "being-at-the-telephone." He says, "...*he is at the telephone*, he is always there, he belongs to the telephone, he is at once riveted and destined there."[15]

What is this telephone, this *tele*/distance—*phone*/ voice, the voice that comes to us from a distance, the voice that (in its being one) *is* a distance, a measure *of* a distance, at once a bridge across it and, too, the very sound that takes its measure? What is it to have one's being riveted there, unable to move, engrossed, transfixed but somehow also and at the same time destined there, intended there and so always traveling (that is, *moving*) towards it? How can we think these two—rivet and destine—at the same time? What would it mean to do so and why would we want it? I think it has to do with the other, with the way we find ourselves always already in relation to the other, the one that is always already within us and, too, the one(s) we find outside.

In his address, Derrida elaborates that this particular kind of being is, "...hooked up to a multiplicity of voices and answering machines."[16] He says, "His being-there is a being-at-the-telephone, a being for the telephone, in the way that Heidegger speaks of the being for death of *Dasein*."[17] *Da* (there) and *sein* (being) is often translated as existence or presence but is, more simply and more complicatedly, a there-being, a being-there, where 'there' becomes a term at once familiar and also wholly strange. Where are we when we find ourselves being *there*? Where are we when we find ourselves *there*, being? To these questions I will return (again and again) but first return to Derrida's telephonic linking after his brief touch on Heidegger's ontology, a linking in which he reminds us that, for Heidegger, being is always a "being-called." Here Derrida delivers two consecutive formulations that I hope will hover in the mind. The first is a description of *Dasein*, this there-being/being-there, as one that is "summoned, provoked, challenged toward its ownmost possibility of being (ahead of itself)." And then, immediately following, he writes, "And in this way the *Dasein* is summoned by this call from or out of the fall into the 'they.'"[18]

In this brief consideration, Derrida is able to link the gravity of Heidegger's notion that being is always a being for death to the idea that being-called or this "being-at-the-telephone" is also, quite seriously, a "being for the telephone," a being whose existence

is in some fundamental way oriented toward the telephone, being at or with this distance-voice. Derrida's elucidation is analogical and so it is important that Heidegger's conviction is that being is only properly being—can only be in its most full and realized integrity—in the moment that it shows itself to be finite, in the moment or the fact or the occasion of (its) death. Human being, for Heidegger, is always a being for death—a being most proper to itself in the very act of its own dying. So when Derrida articulates that the being he is working to illuminate is one that is a "being for the telephone," what he is arguing for is a kind of being that is most properly itself in the tangle of relations it experiences to this network of voices that are the distance-voice, the distance-voices, the tele-phone. In other words, this being is one that is always already "hooked up to a multiplicity of voices and

answering machines"—hooked up, attached to, entangled in this web of voices in which the telephone is both the context and its instrument.

What does it mean to be undetachable from answering *machines* (machines that answer, objects that have response-ability)? I keep wondering what it means, what the implications are of this relation of being "hooked up"? The expression implies a cleaving: a snare, a needle or a hook sunk deep in the flesh that tethers the body, often to a line that attaches to some other thing or being that perhaps also has these hooks sunk deep. Other senses that resonate inside this being hooked up denote entanglements of flesh, sexual encounters, or even sometimes, as in "the hook up," the line through which one finally scores the narcotic plug we might desire. These possibilities are important

because of what they tell us about the ways we meet the other.

What does it mean that "... the called one is...summoned, provoked, challenged toward its ownmost possibility of being (ahead of itself)"? If we think of the telephone as a network of voices to which we are always already tethered (hooked up, hooked in, hooked on), then we are summoned by these voices—a summons: a call that is stronger than a call, more urgent. This summons is always a request, sometimes an order, to appear: to show ourselves, to make plain our being for (or before) an other, to be present, to present ourselves. Provocation exists in a different register, but operates in much the same way: it incites, it arouses and—like a summons—a provocation causes us to rise (up), to appear. To be challenged is also to have to take a stand, to come forth and accept the

terms of contest, perhaps to dispute or call into question but all of these involve a showing of being, a being-there more immediately, more obviously (apparently—appearing) engaged. For Derrida, being at the telephone, being for the distance-voice, is the condition through which we are at once tethered to and also always moving toward answering that call. It is in this inevitable moving toward that we step into the possibility of the being that is most proper to us. Our fullest integrity is thus intimately bound up in, indeed, inextricable from, the "multiplicity of voices." And this multiplicity, this network, precedes us—the condition of our most manifested being (to be in relation to that call)—always exists ahead of ourselves. The most-my-own possibility of being, therefore, lies outside of me, "ahead" of me, in the vast network of others that comprise the interrelated distance-voices I (will) respond to. It is for them that I am. It is for them that I make. It is for them that I perform, and so become, myself.

In this way, I am summoned to present myself—I am called into presence/ appearance—and in so being, I am called forth from "out of the fall into the 'they,'" into being-with, into the "irreducible necessity of collectivity." This is our double life. In all the doubling the works in this exhibition reveal and encourage us to think, this is perhaps the most pressing. There are those who imagine we are separate selves: many of us are taught, encouraged, to think so. In some ways, capitalism requires it of us, rewards those of us who imagine that we are whole unto ourselves, impermeable. The works in *Double Life* resist this reading, asking us instead to see the ways in which being is itself always a being in between—it can only happen in the spans between us, it can only be in, with, for others.

In this sense of the real, Tsang's *Miss Communication and Mr:Re* raises a profound ontological possibility. What emerges throughout the piece is a being that refuses to be singular, that slides and swells and siphons off, that opens up to audience and collaborator alike, generating a space of experimentation, a network, moving and pulsing between. Towards the end of the piece, Moten raises the possibility that the ultimate connection, the fated sense that someone is meant for you means not that they complete you but that, as he says, "they *in*complete you," suggesting *this* as the ultimate connective possibility. We hear him say:

> ...and what it means to be with somebody is that you get cut all the time and bruuuuised and you lose part of your foot, you know, and and and your arm fades out but there aint nothin you can do about it, see? or, being meaning for one another...it it it it's always at a loss, I mean, it always happens *as* a loss, it always leaves you at a loss but but but you want it anyway, right? I mean, ain't nothin you could do about it, ain't nothin you can do about wanting it. It's rough-edged, *hard* edged, you know? Ummm...incomplete or it *in*completes you, you know, fuck Tom Cruise and that... fuckin...what was that movie?— 'you complete me'—No! That's not...Fate, being meant for somebody means they incomplete you, right? They tear you up, they mess you up and you mess them up and it's all messed up.
> Your heart is a strong muscle. It squeezes very good.

He puts forth in this riffing thinking that "what it means to be with somebody" is that you *lose* parts, that you get *in*completed, dispersed in some fundamental way. *This* is the nature of being. This is the nature of being-with: coming apart, coming into parts, seeing we are all parts—multiples, pluralities. There is a politic here. We are interwoven, inter-written. We may see ourselves as separate, wholes, but we are constantly sliding through a field of messages: porous and doubling, answering, calling, receiving. We need each other to be recognized, I can not *be* alone. Because of this, I can not be impervious to the experiences, the sufferings, the joys, of others, another. We are leaving messages all the time. I (is) am somewhere in between.

Double life.
*Double Life.*

In thinking through a title for this piece, I seize on the one I've used: Your heart is a strong muscle, it squeezes very good. I write "seize" but that implies a kind of will, an agency, a way in which I chose and conquered these words, took possession of them. But what really happened is something quite different: they took possession of me. I heard Fred Moten say them and then, you could say, I started to hear voices—his voice(s). I am inter-written, inter-messaged, in-between. Your heart is a strong muscle, it squeezes very good. I start to hear it everywhere, wake up and hear myself whispering it to the air, the atoms, the molecules in my bedroom. Your heart is a strong muscle, it squeezes very good. On the morning when I finally part with this text, when I send it off to be publicked, published, I wonder again and for the first time at whose words these are. Moten says a name right after saying them: Ramin Tabibiazar, Ramin Tabibiazar, Ramin Tabibiazar. He says it three times. And so I look it up, wanting to find this poet whose words have inter-written me. The search engine calls up a series of pages on a doctor in Santa Monica and I assume I've gotten it wrong. But suddenly I realize Moten has been talking about a heart test, a medical experience and I am laughing out loud, hard to stop, laughing to the dishes waiting for me in the sink. A marvel: Ramin Tabibiazar, a doctor in Santa Monica. I can only guess that he told Moten: your heart is a strong muscle, it squeezes very good. We are inter-written, interwoven, caring for our parts, all parts—dispersed, multiple, double. Life.

1    "3/6 Social Text 30th Anniversary Panel: panelist, Fred Moten," *YouTube* video, 9:36, Columbia University, November 13, 2009, https://www.youtube.com/wach?v=rLrTYbD-sKw.

2    Judith Butler, "Acting in Concert," in *Undoing Gender*, 1–16 (New York: Routledge, 2004), 8.

3    Ibid., 1.

4    Ibid., 2.

5    Giorgio Agamben, *Remnants of Auschwitz: The Witness and the Archive*, trans. Daniel Heller-Roazen (New York: Zone Books, 2002),142–48.

6    Behm, "'Mountains of Encounter,' but whose story?," Haegue Yang website, 2007, http://www.heikejung.de/work-MountainsOfEncounter.html.

7    Édouard Glissant, "Of Opacity," in *Poetics of Relation* (Ann Arbor: The University of Michigan Press, 1997), 189-190.

8    Ibid., 190.

9    Ibid.

10   Tate. "The Tanks: Haegue Yang," *YouTube* video, 4:37, September 21, 2012, https://www.youtube.com/watch?v=Ef8Af9OO2oQ.

11   Carnegie International. "Life on Mars: 2008 Carnegie International Artist's Interview, Haegue Yang," *YouTube* video, 7:16, June 23, 2008, https://www.youtube.com/watch?v=g4KnN0-u0rw.

12   Wu Tsang with Fred Moten, *Miss Communication and Mr:Re*, Contemporary Art Museum Houston 2014.

13   Joseph T. Shipleys, *Dictionary of Word Origins* (Dorset Press, 1995), 368.

14   Jacques Derrida, "Ulysses Gramophone: Hear Say Yes in Joyce," in *Acts of Literature*, ed. Derek Attridge, 253–309 (New York & London: Routledge, 1992), 273.

15   Ibid.

16   Ibid.

17   Ibid.

18   Ibid.

# Plates

The following pages document the installation of *Double Life* in CAMH's Brown Foundation Gallery. In the center of the gallery, opposite the entrance, Jérôme Bel's video *Veronique Doisneau* (2004) was projected above a dance floor that replicated the stage in the video. Dance performances of Bel's work *Cédric Andrieux* (2009/2015) were later presented on this stage. To the left of the entrance, four coursing spotlights illuminated the Venetian blind architecture of Haegue Yang's *Mountains of Encounter* (2008) and two floodlights cast pools of light on the floor in the center of the work. To the far right, two works by Wu Tsang were housed within a compartentalized structure purpose-built for this presentation: in its front, the 16mm film loop *For how we perceived a life (Take 3)* (2012) was screened in a fully enclosed room; *Miss Communication and Mr:Re* (2014)—a two-channel audio and video work created by Tsang in collaboration with noted poet and cultural theorist Fred Moten—was projected in an open bay at its rear.

In the hierarchy of the Pa

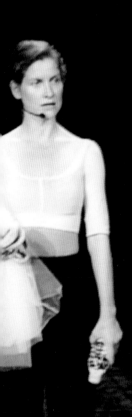

...era Ballet, I am a "Subject"

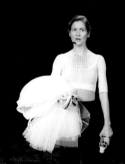

The meeting with Rudolf Noureev

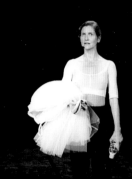

he understood everything

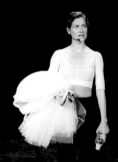

that it was through the mastery of the language of dance

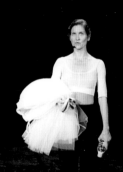

that emotion is created

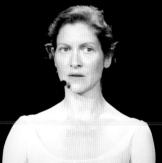

Above all he told us to respect the sense of movement

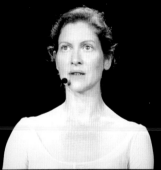

and not to interpret it

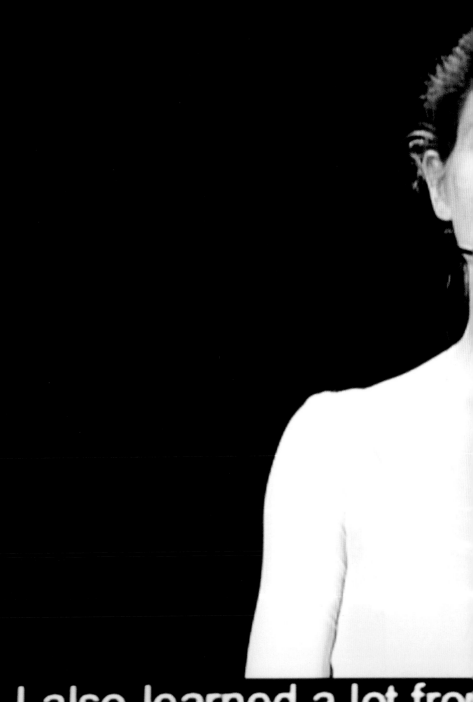

I also learned a lot fror

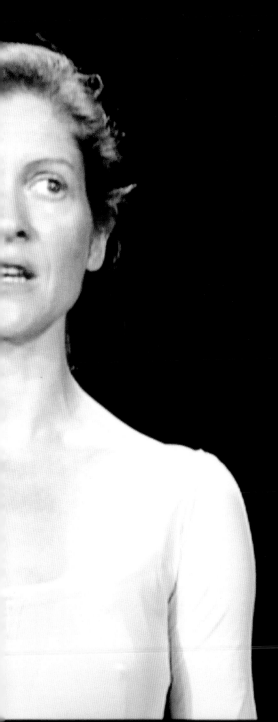

Merce Cunningham

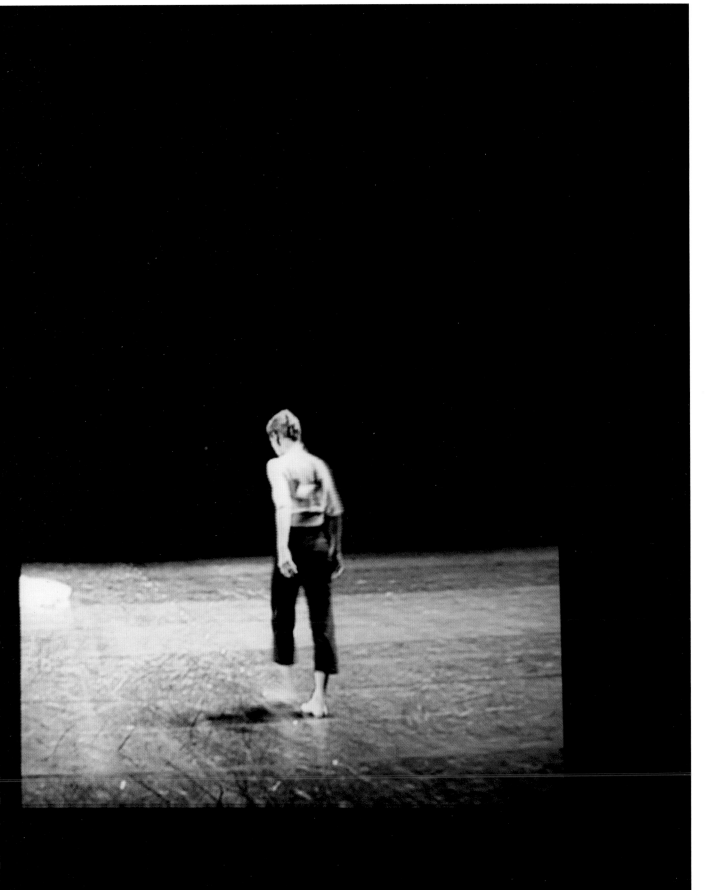

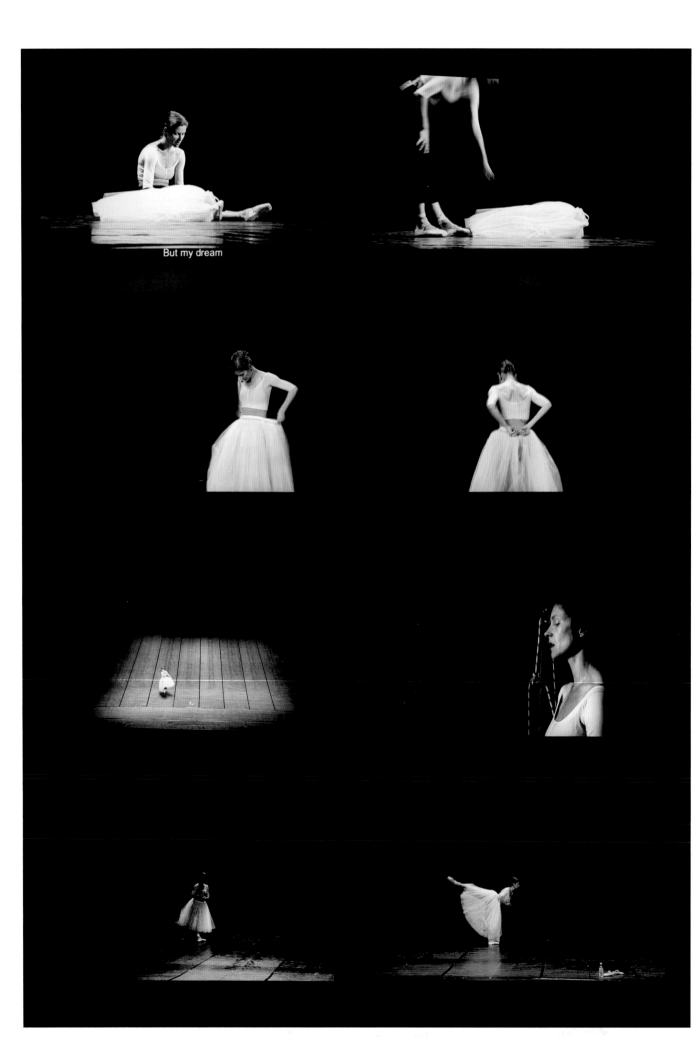

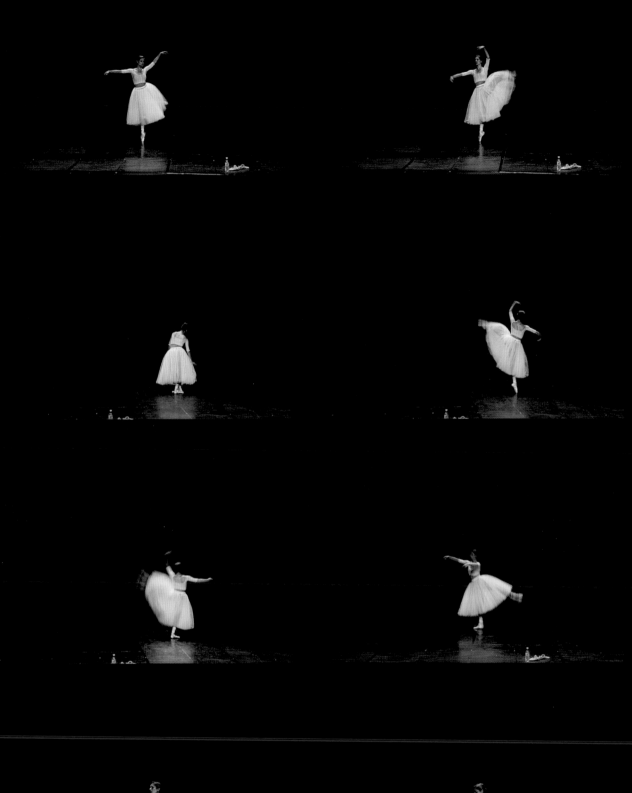

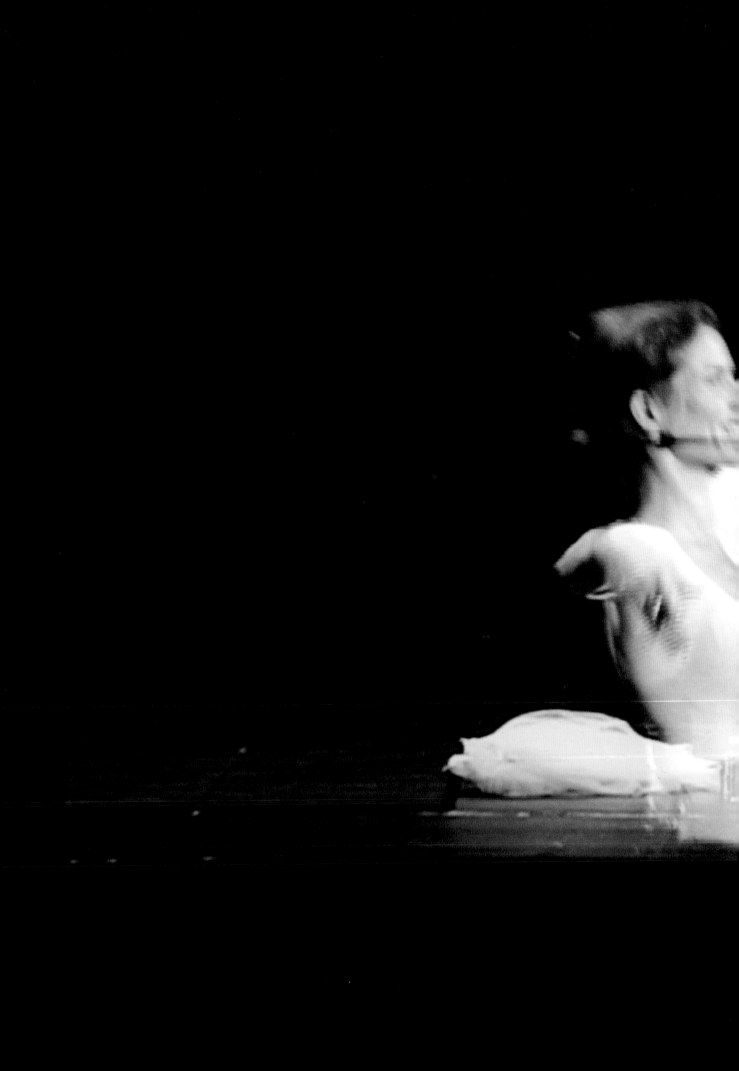

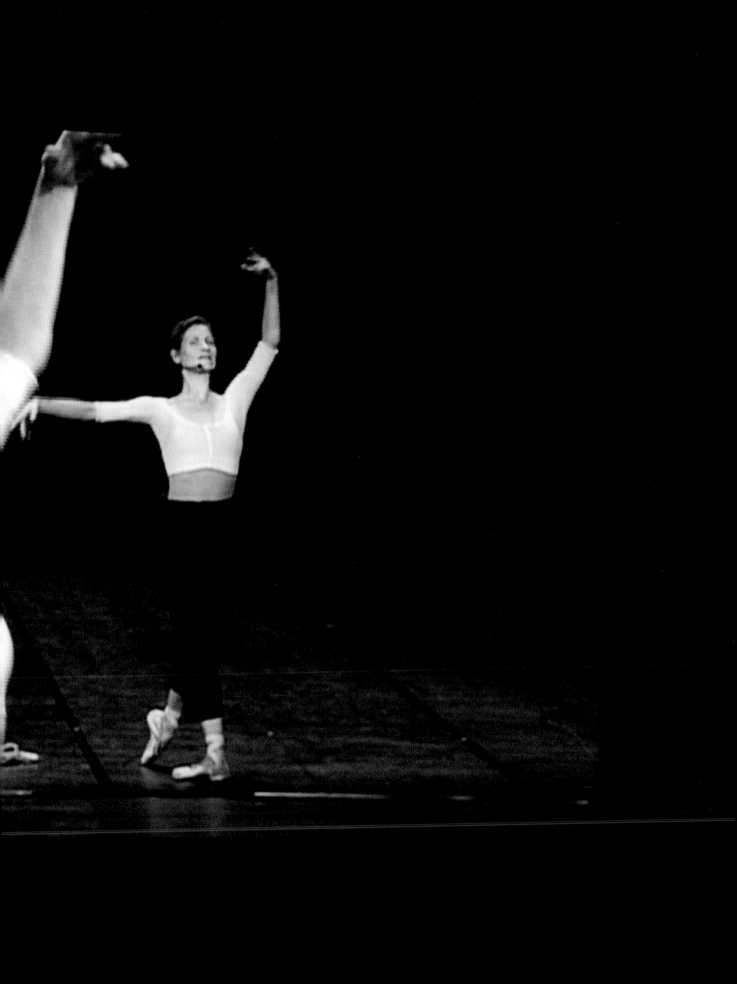

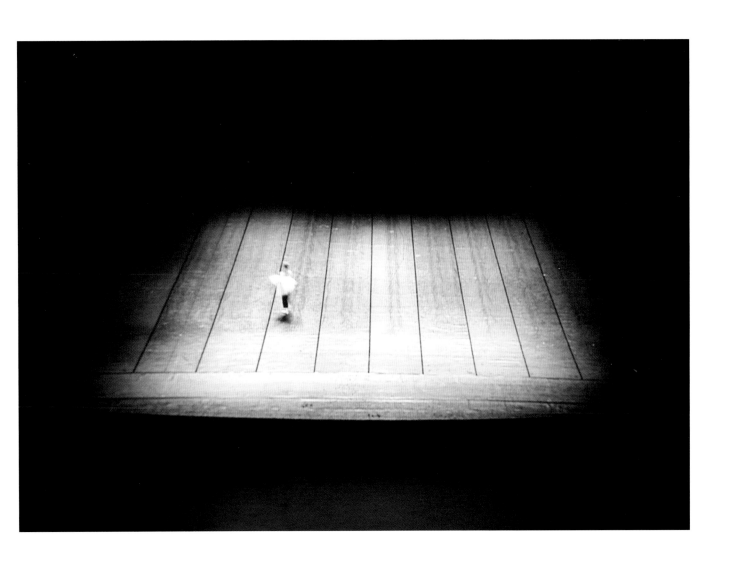

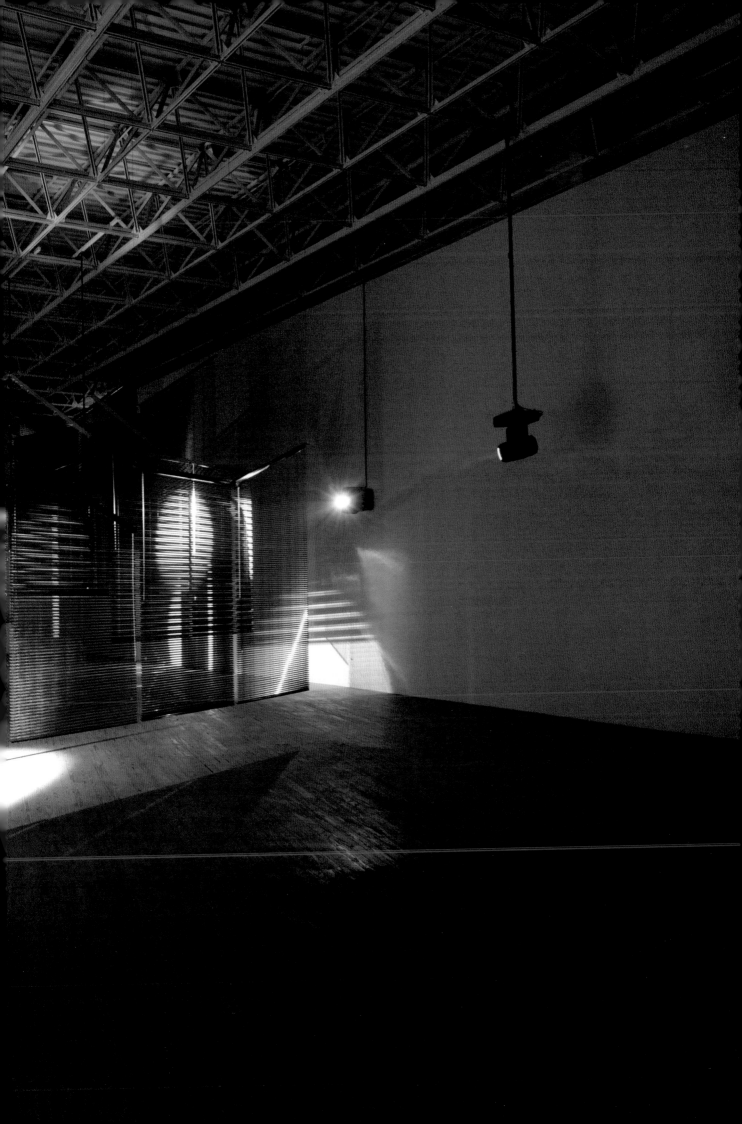

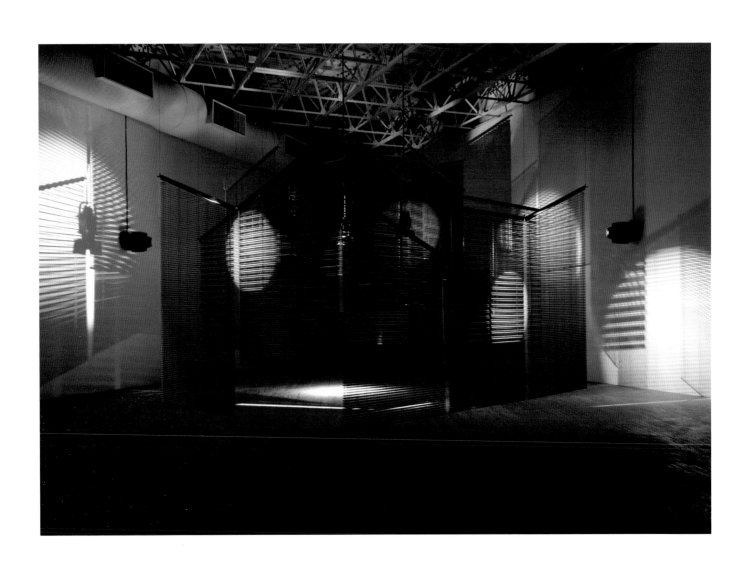

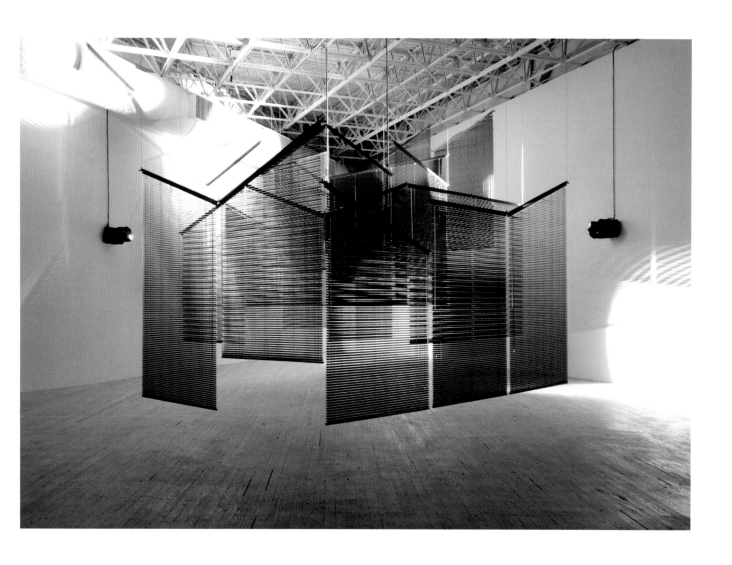

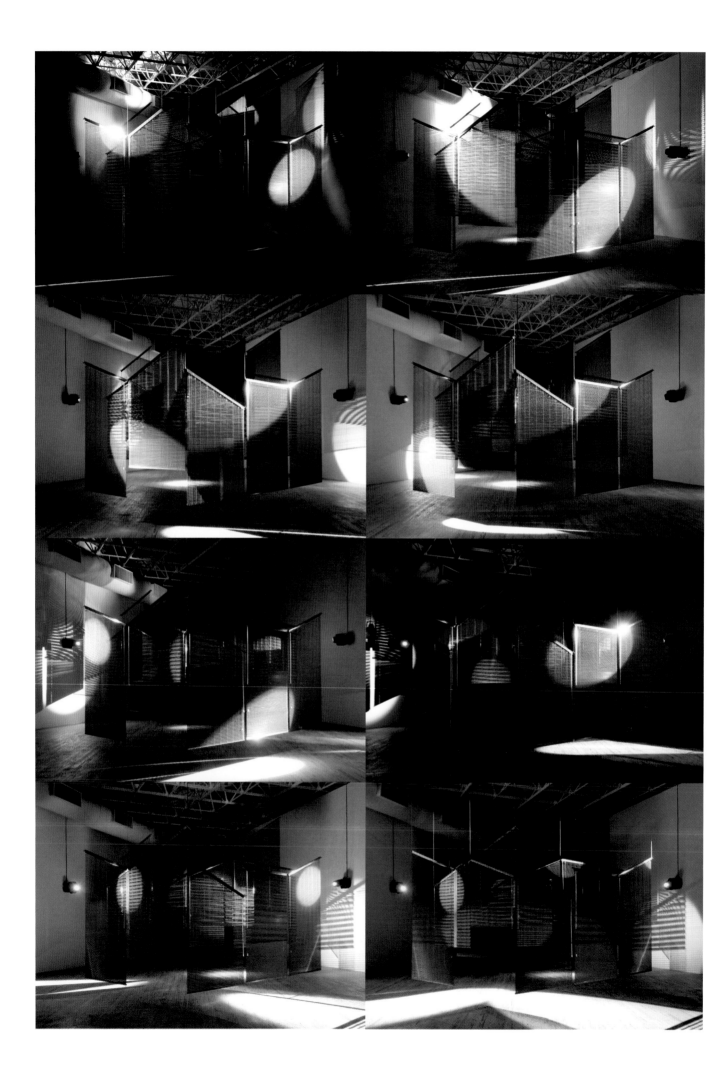

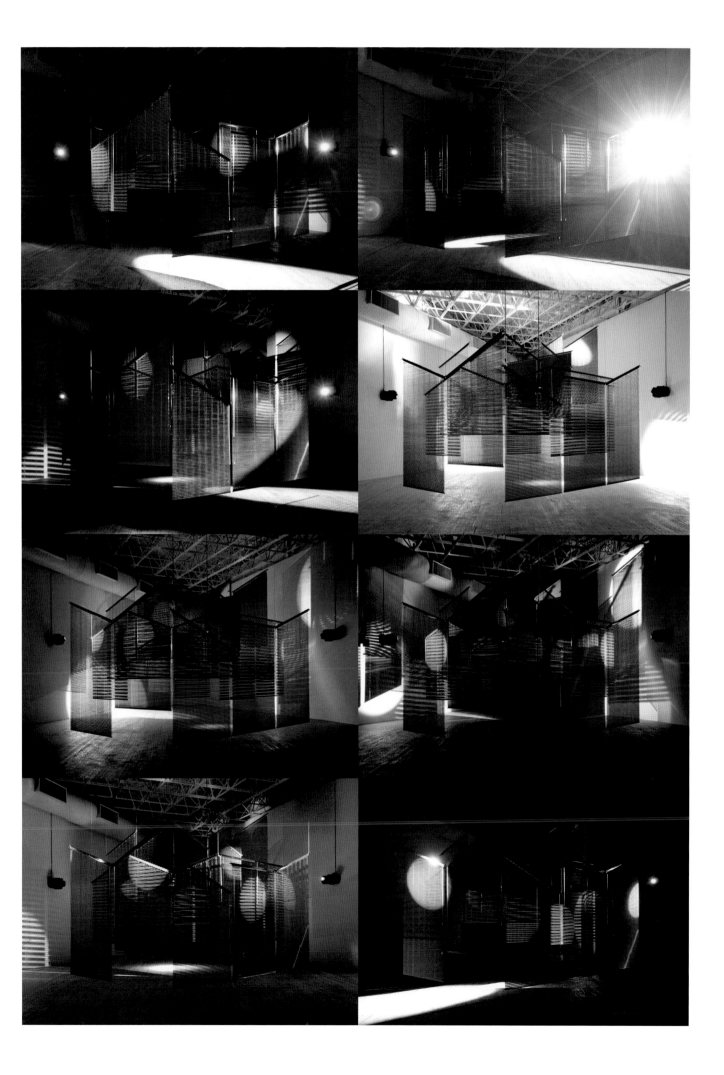

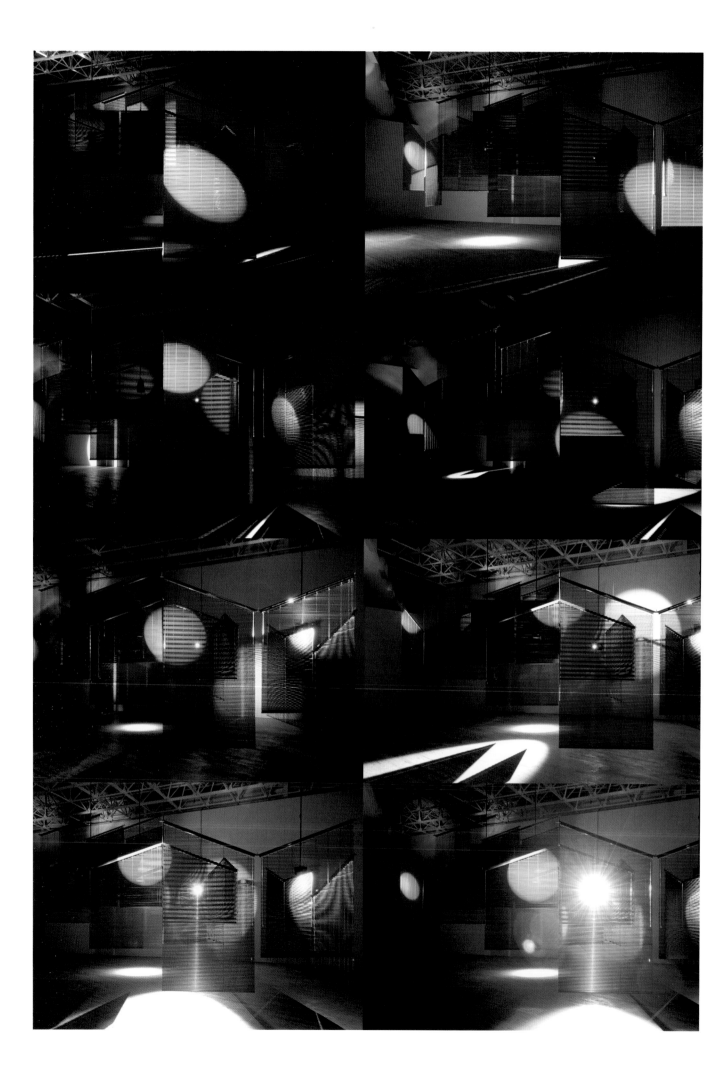

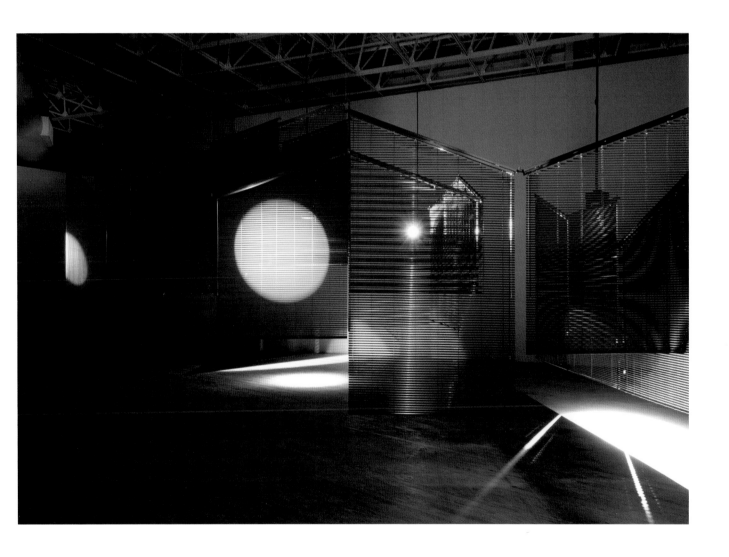

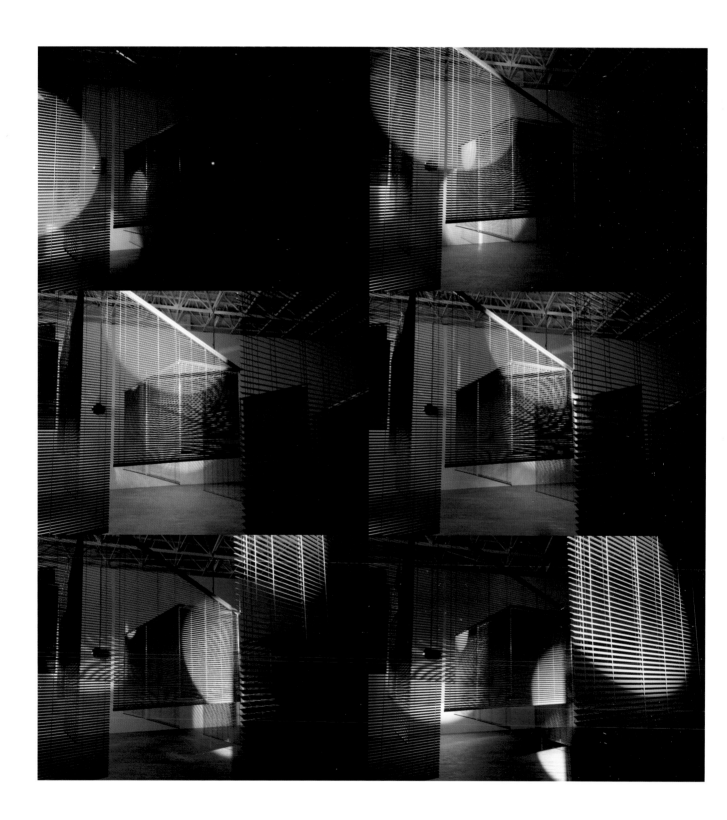

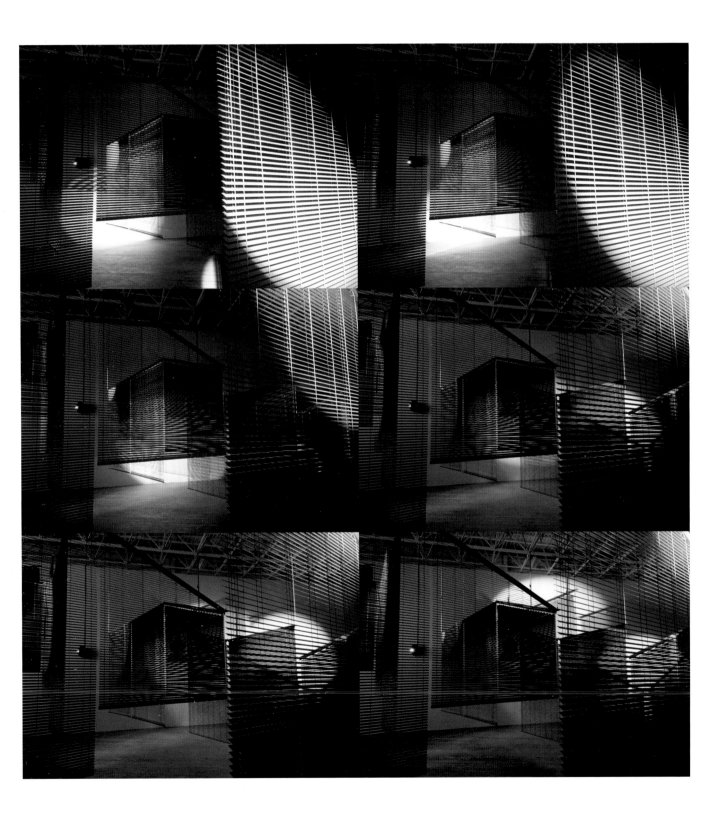

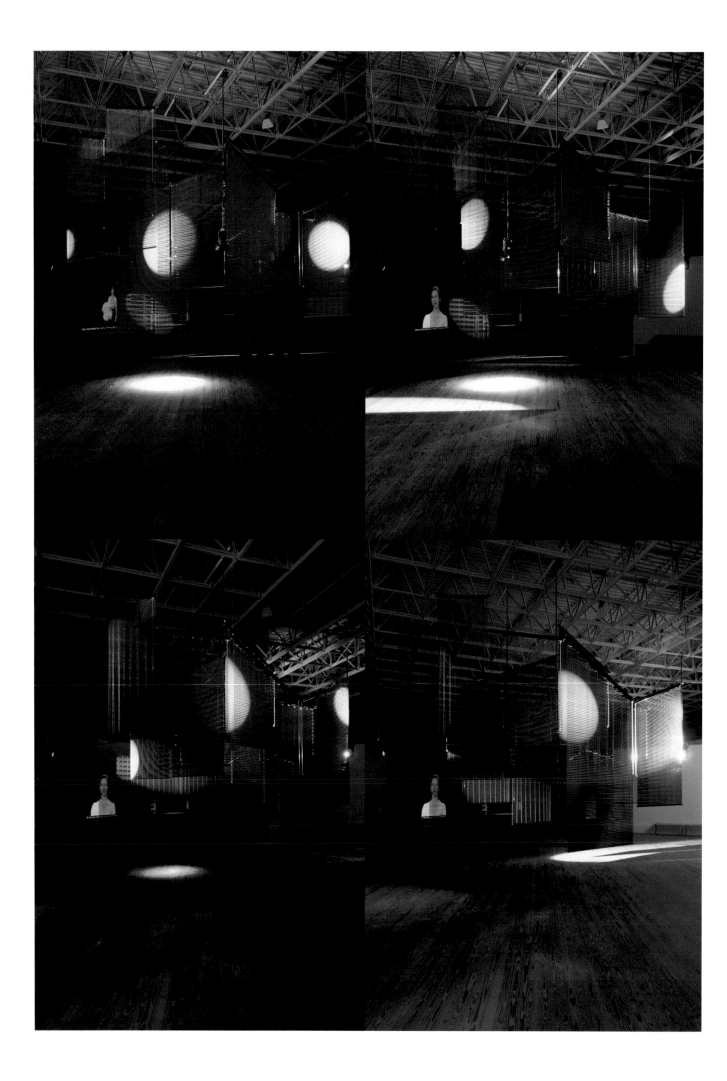

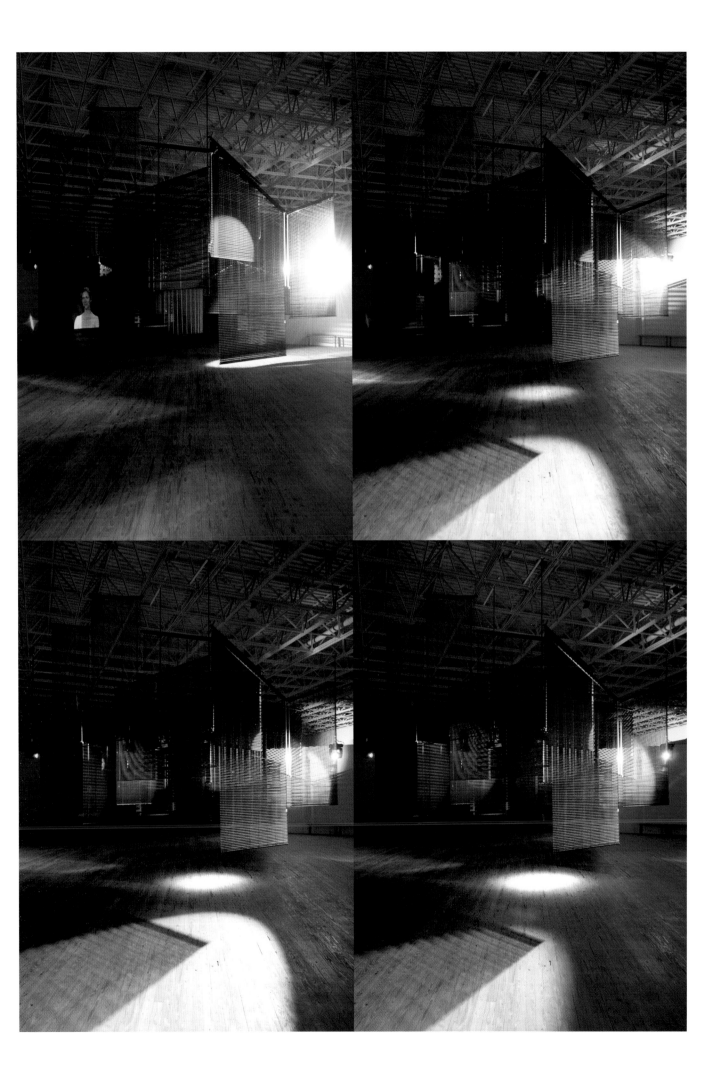

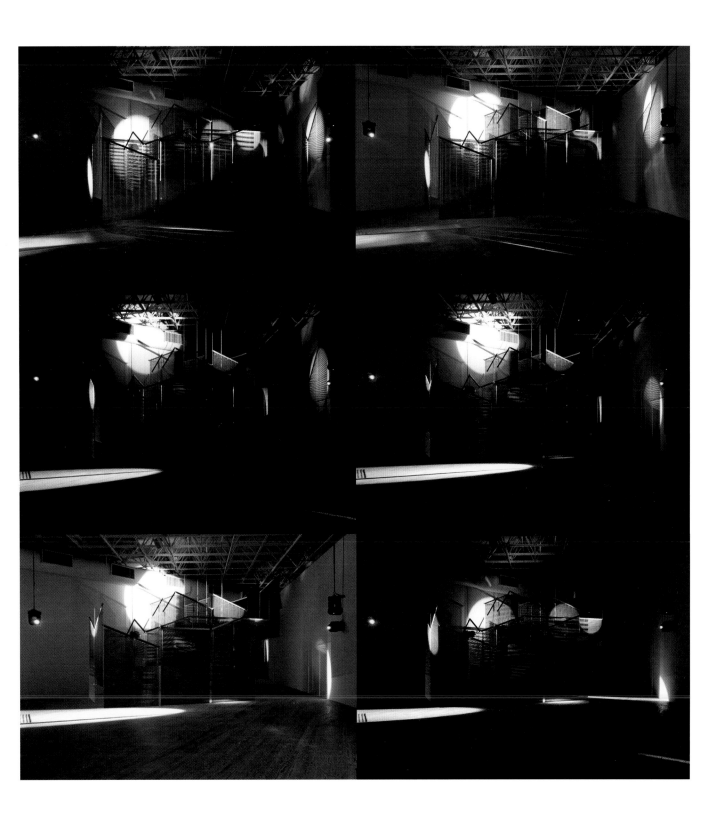

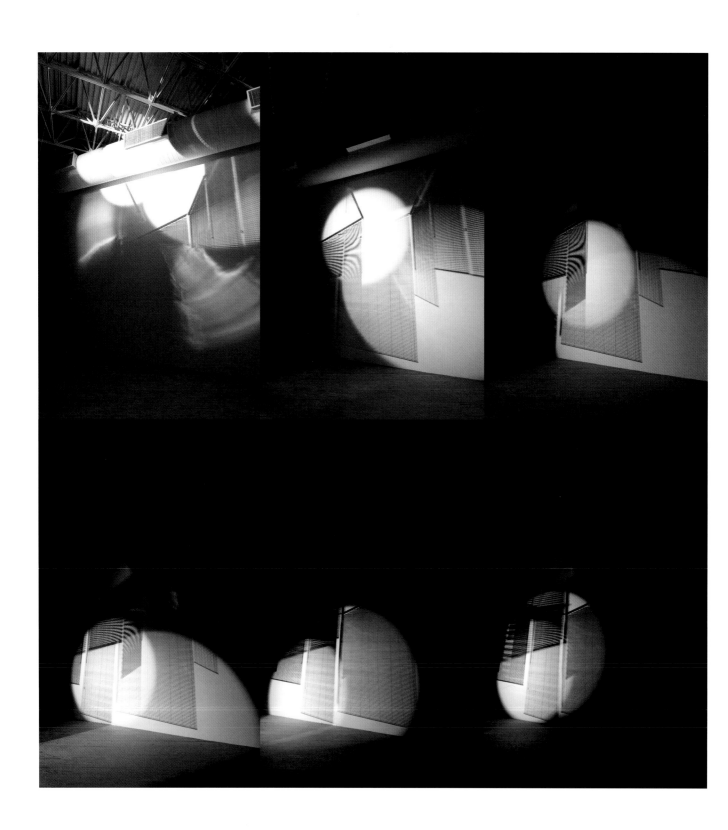

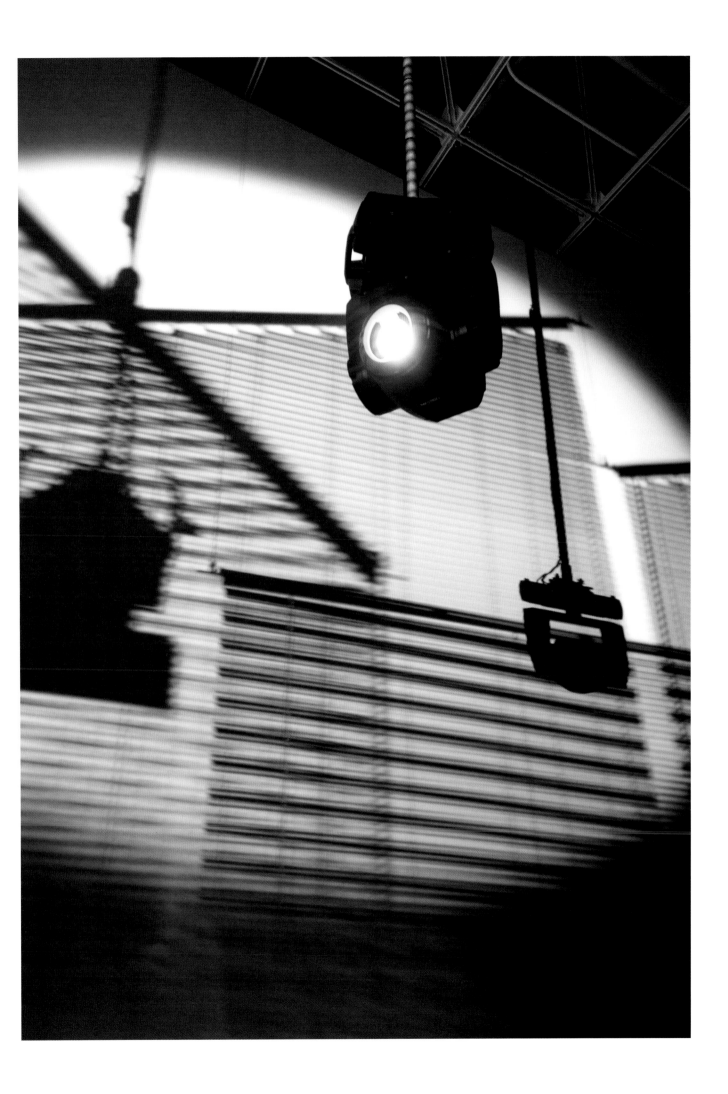

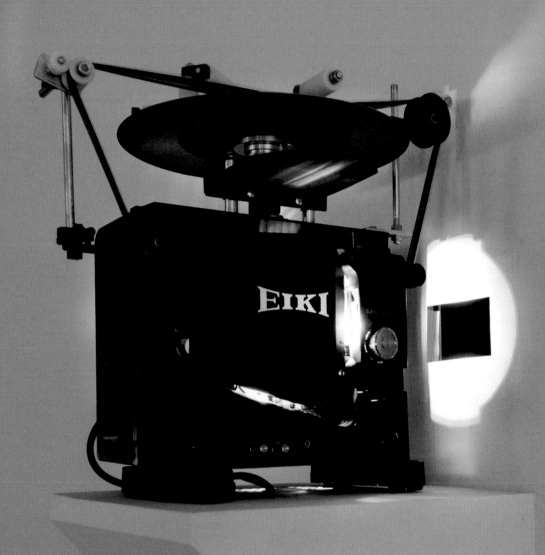

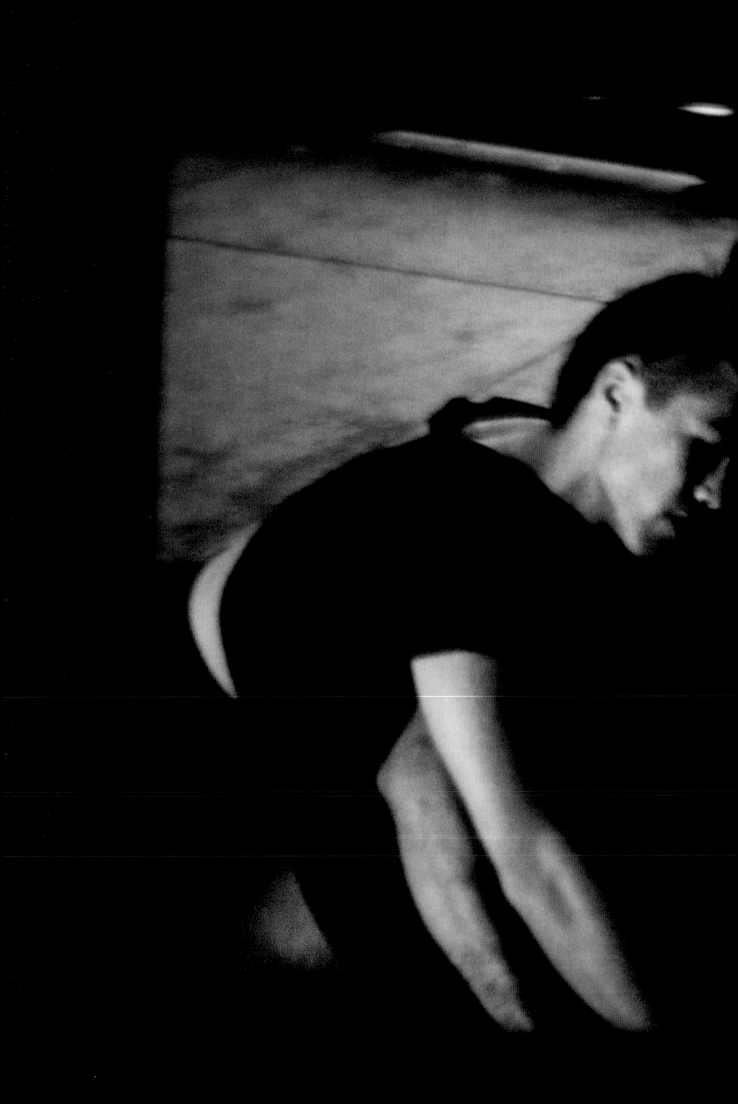

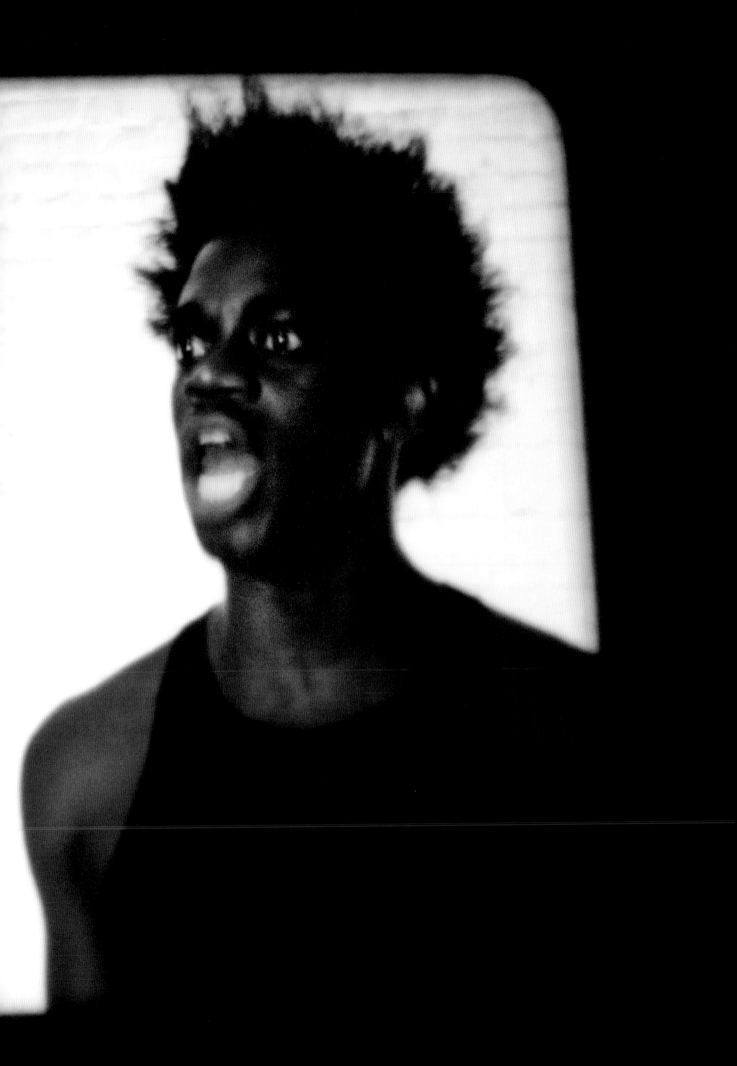

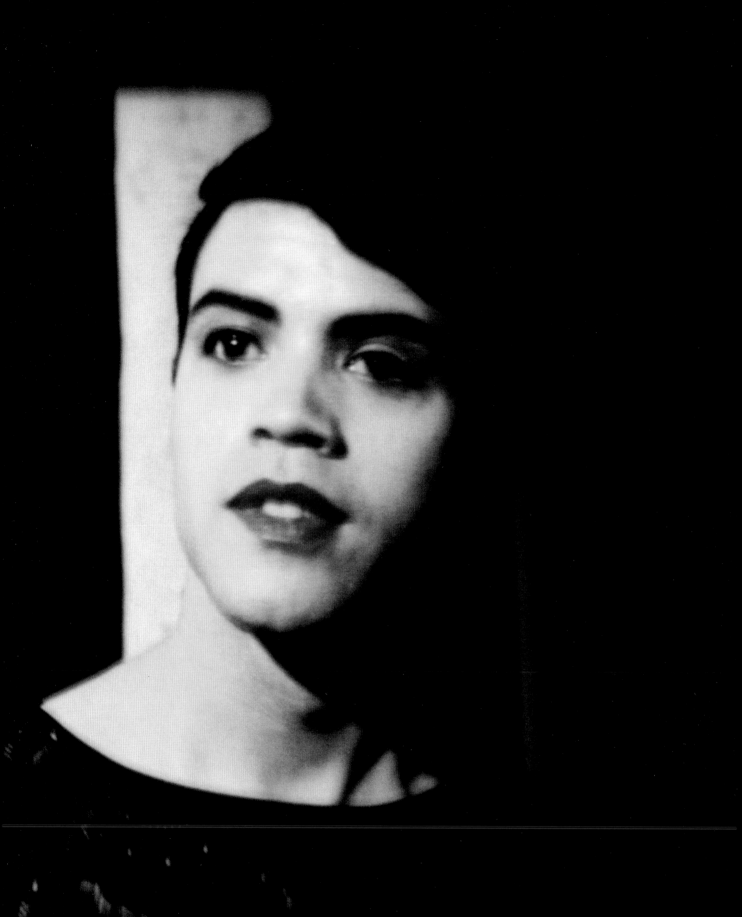

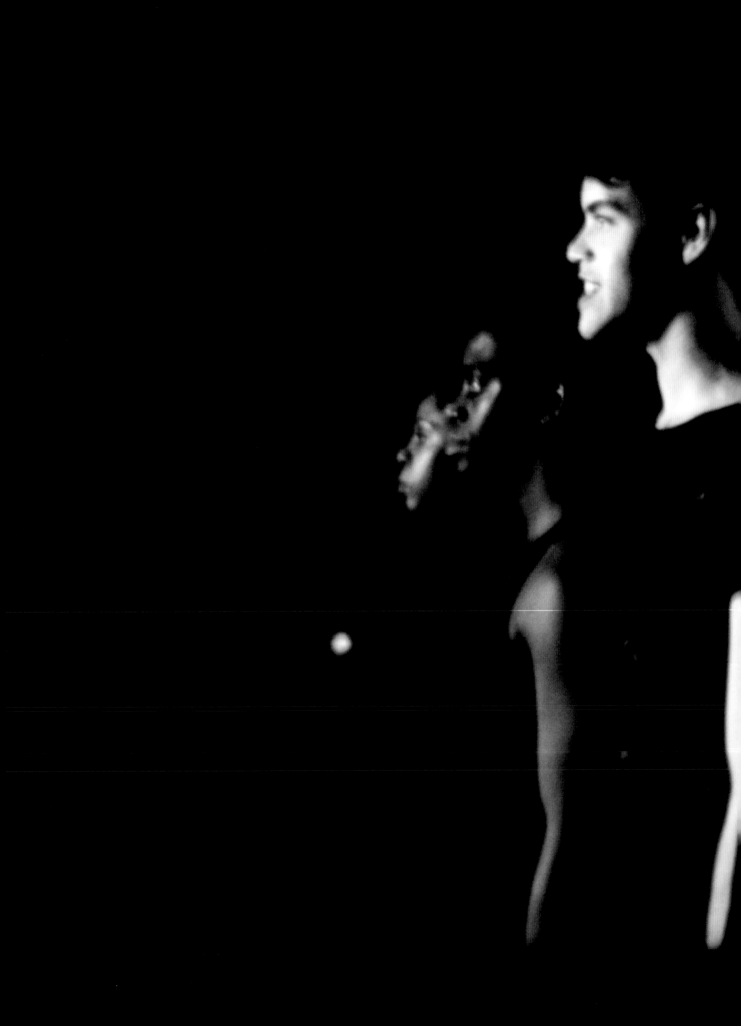

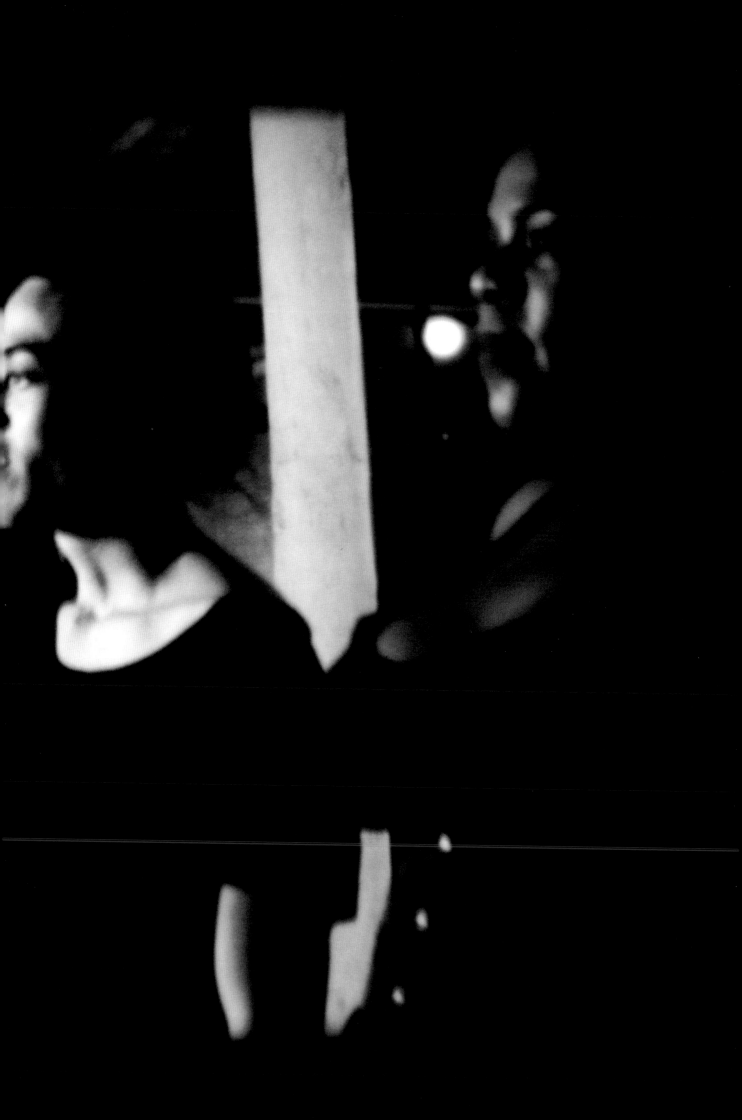

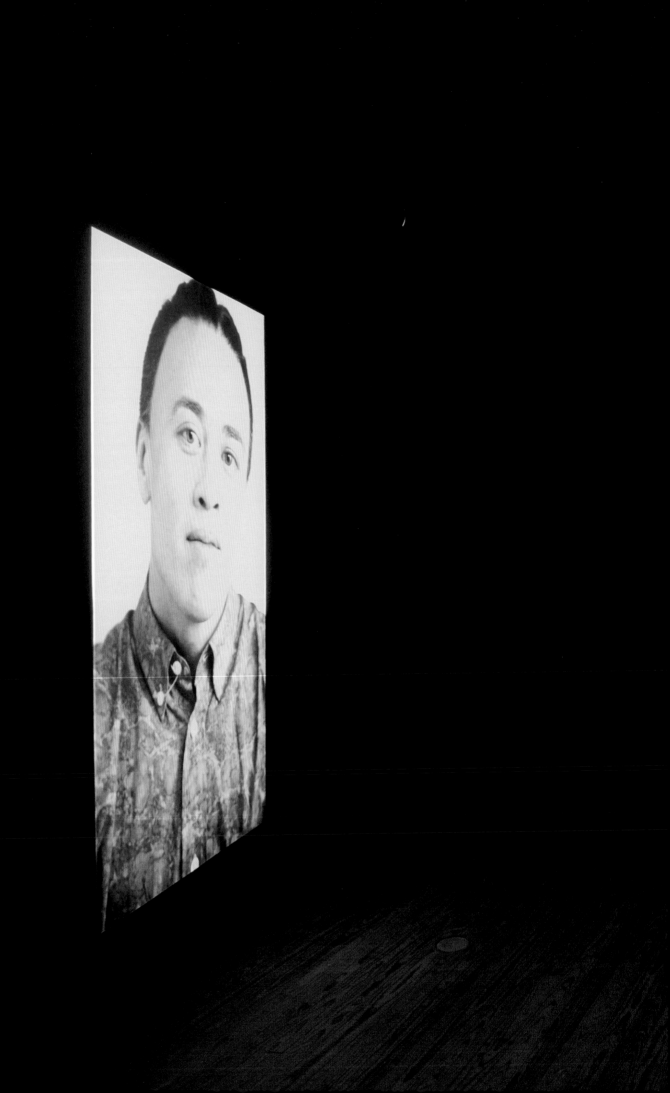

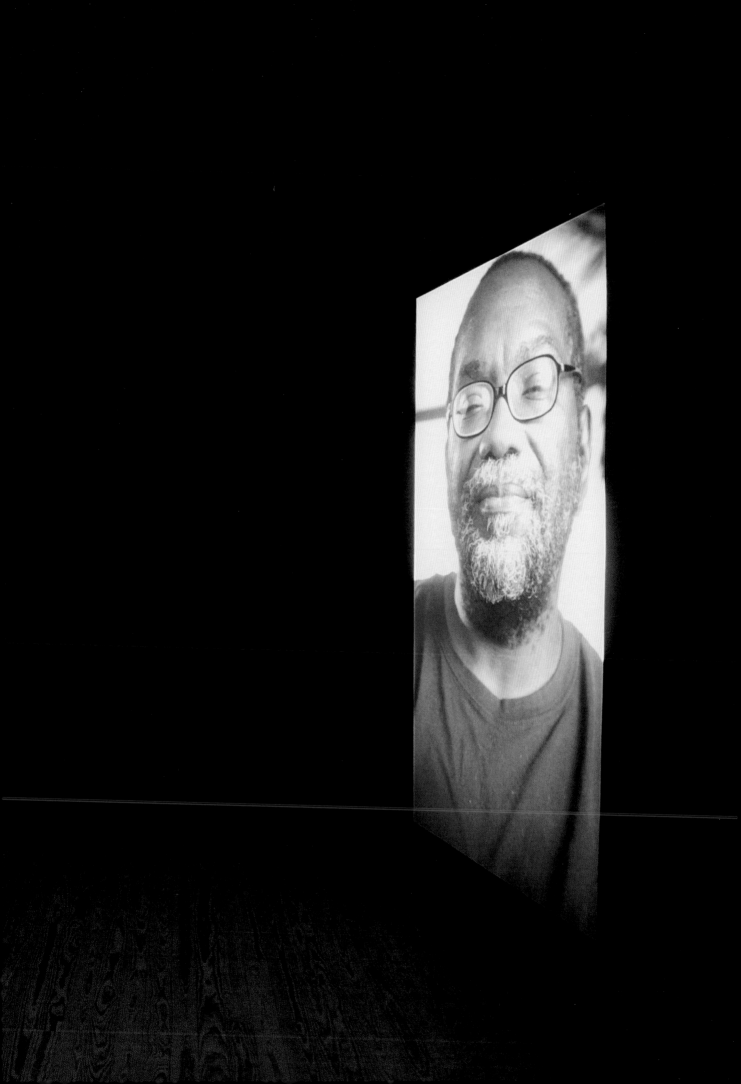

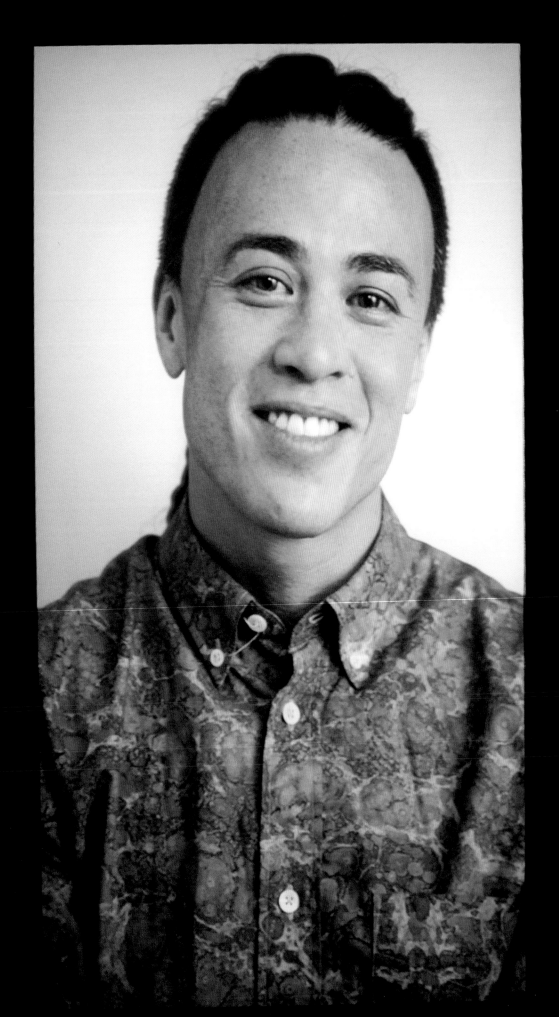

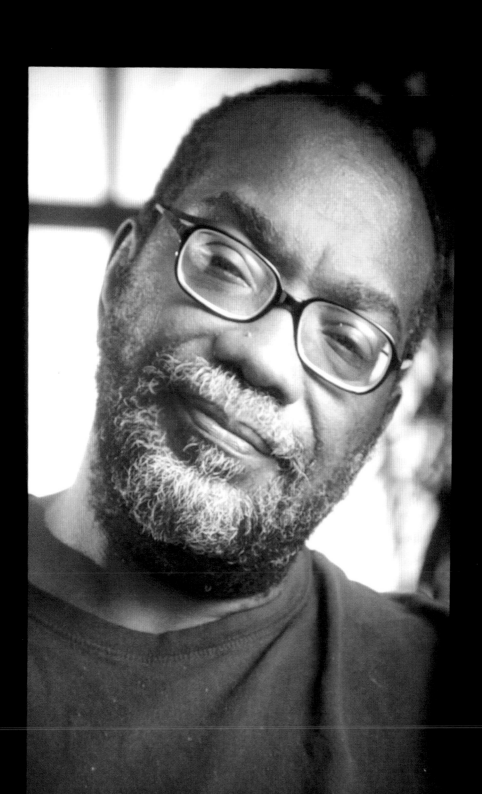

# Works in the Exhibition

## Jérôme Bel

*Cédric Andrieux*, 2009/2015
Courtesy the artists
Performances: Saturday,
January 30 and Sunday,
January 31, 2015
Conceived for presentation
on a proscenium stage, Bel
and Andrieux revised and
re-choreographed this
work for *Double Life*, where
audiences surrounded the
dance floor on three sides.

*Veronique Doisneau*, 2004
Video: color, sound, 31:00
minutes
Commissioned by the Opéra
National de Paris
Filmed at the Palais Garnier,
Paris
Courtesy the artist and
Telemondis, France

## Wu Tsang

*For how we perceived a life
(Take 3)*, 2012
16mm film: color, sound, 9:34
minutes (loop)
Courtesy the artist; Clifton
Benevento, New York;
Michael Benevento, Los
Angeles; and Isabella
Bortolozzi, Berlin

Performers: Desiree Burch,
Cherrye Davis, Nicholas
Gorham, Mikeah Jennings,
and Wu Tsang
Director: Wu Tsang
Producer: Travis Chamberlain
Director of Photography:
Martina Radwan
Assistant Camera: Alvah
Chomes
Gaffer: Derek Wright
Makeup: Gage Boone
Production Assitants:
Halston Bruce, Naomi Huth,
and Loreli Ramirez
Music: Total Freedom

Characters (In order of
appearance): Octavia St.
Laurent, *Paris is Burning*
(1990); Venus Xtravaganza,
Paris is Burning (1990); Crystal
LaBeija, *The Queen* (1968);
Unidentified Photographer,
*Paris is Burning* (1990);
Jennie Livingston, *Paris
is Burning* archives (UCLA
Film & Television Archives);
Junior LaBeija, *Paris is
Burning* archives (UCLA
Film & Television Archives);
Unidentified Kids, *Paris is
Burning* (1990); Grandfather
Hector Xtravaganza,
interview, June 2011

## Wu Tsang with Fred Moten

*Miss Communication and
Mr:Re*, 2014
Two-channel HD video: color,
sound, 15:00 minutes
Courtesy the artist; Clifton
Benevento, New York;
Michael Benevento, Los
Angeles; and Isabella
Bortolozzi, Berlin

Performers:
Fred Moten and Wu Tsang

Producer:
Melissa Haizlip

Edited by:
Wu Tsang

Acting Coach:
Bret Porter

Acting Technique Instructor:
Lisa Robertson

Director of Photography:
Antonio Cisneros

1st Assistant Camera:
Esther Woodworth

B-Camera Operator:
Ezra Riley

B-Camera
1st Assistant Camera:
Logan Turner

Digital Imaging Technician
and 2nd Assistant Camera:
Justin Kane

Gaffer:
Christian Janss

Key Grip:
Nate Elegino

Grip and Driver:
Alfredo Olmos

Location Sound:
Adam Douglass

Hair and Makeup:
Heather Galipo

Post Sound Mixer:
Lucien McRobbie

## Haegue Yang

*Mountains of Encounter*, 2008
Aluminum Venetian blinds,
powder-coated aluminum
hanging structure,
steel wire, moving spotlights,
floodlights, electrical cable,
and hardware
Dimensions variable
Courtesy the artist; Galerie
Wien Lukatsch, Berlin; and
Greene Naftali, New York

## Wu Tsang

Born 1982 in Worcester, Massachusetts
Lives and works in Los Angeles

Wu Tsang is a multi-media artist and award-winning filmmaker. His films, performances, and installations investigate complex layers of human life and basic human problems of belonging and conflict. Using a variety of storytelling techniques such as magical realism and personal narrative, Tsang creates mythologies and emotional narratives about the struggle to find adequate identities among nonhomogeneous subcultural communities. His work has been presented at museums and film festivals internationally. Tsang's first feature WILDNESS premiered at MoMA's Documentary Fortnight in 2012, Hot Docs (Toronto), and won the Grand Jury Prize for Outstanding Documentary at OUTFEST (Los Angeles). His recent short YOU'RE DEAD TO ME premiered on PBS and won the 2014 Imagen Award for Best Short. Tsang is a 2015 Creative Capital Fellow, a 2014 Rockerfeller Bellagio Creative Arts Fellow, and was a 2012 Film Independent Project Involve Directing Fellow. Tsang received his BFA from the School of the Art Institute of Chicago in 2004 and his MFA in Interdisciplinary Studio from UCLA in 2010.

Selected Group Exhibitions

2014
Don't You Know Who I am? Art After Identity Politics, MuHKA, Antwerp, Belgium
Made in L.A., Hammer Museum Biennial, Los Angeles

2013
Blues for Smoke, Whitney Museum, New York

2012
Blues for Smoke, The Geffen Contemporary at MOCA, Los Angeles
Gwangju Bienniale 2012, Bwangju, Korea
First Among Equals, ICA Philadelphia
The Ungovernables, New Musuem, New York, Whitney Biennial, New York

2008
Our Bodies Our Selves, Montehermoso Cultural Center, Vitoria-Gasteiz, Spain

2007
Shared Women, Los Angeles Contemporary Exhibitions, Los Angeles

2006
Feminisms in the Electronic Landscape, Espai d'Art Contemporani, Castellon, Spain
New Ghost Entertainment Entitled, Städtische Galerie Kunsthaus, Dresden, Germany

2005
I Beg Your Pardon, Vera List Center for Art and Politics, New York
Multitudinario, Sala de Art Publico Siqueiros, Mexico City, Mexico

2003
Listen Translate Translate Record, Andrew Kreps, New York

## Fred Moten

Born 1962 in Las Vegas, Nevada
Lives and works in Los Angeles

Fred Moten is a Professor of English at University of California Riverside. Through poetry, performance, critical theory, and performance studies, he uses narrative to address issues of blackness. In 2009 Moten was Critic-in-Residence at In Transit 09: Resistance of the Object, The Performing Arts Festival at the House of World Cultures, Berlin, and was also recognized as one of ten "New American Poets" by the Poetry Society of America; in 2011 he was a Visiting Scholar and Artist-in-Residence at Pratt Institute; in 2012, he was the Whitney J. Oates Fellow in the Humanities Council and the Center for African American Studies at Princeton University and a member of the writing faculty of the Milton Avery Graduate School of the Arts, Bard College; and in 2013 he was a guest faculty member in the Summer Writers Program at the Jack Kerouac School of Disembodied Poetics, Naropa Institute. He was also a member of the Critical Theory Institute at the University of California Irvine from 2002 to 2004 and a member of the Board of Directors for the Center for Lesbian and Gay Studies at the City University of New York from 2001 to 2002. Moten is the co-founder of co-publisher (with Joseph Donahue) of the small literary press Three Count Pour.

Selected Performances

2014
Untouchables (featuring boychild), Stedelijk Museum, Amsterdam, Netherlands
Moved by the Motion (featuring boychild), DiverseWorks, Houston
Moved by the Motion (featuring boychild), The Geffen Contemporary, Los Angeles
Moved by the Motion (featuring boychild), MCA Chicago, Chicago

2013
Breakdown in collaboration with Kelela and Ashland Mines, The Tanks at Tate Modern, London, UK

2011
Full Body Quotation, Performa 11, New Museum, New York
THE TABLE, with TOTAL FREEDOM (Ashland Mines), KINGDOM (Ezra Rubin), and NGUZUNGUZU (Asma Maroof & Daniel Pineda), New Museum, New York

2010
Ecstatic Resistance, X Initiative, New York

2009
New Original Works Festival, REDCAT, Los Angeles

2008
Open Studio, REDCAT, Los Angeles

## Bibliography

*The Little Edges*, Wesleyan University Press, 2014.

*The Feel Trio*, Letter Machine Editions, 2014.

*The Undercommons: Fugitive Planning and Black Study* (with Stefano Harney), Minor Compositions/ Autonomedia, 2013.

"Liner Notes for Lick Piece," Valerie Cassel Oliver, ed. *Ben Patterson: Born in the State of FLUX/us*, Contemporary Arts Museum Houston, 2012, 212–20.

*B Jenkins*, Duke University Press, 2010.

"The Case of Blackness," *Criticism* 50:2, Spring 2008, 177–218.

*Hughson's Tavern*, Leon Works, 2008.

*I ran from it but was still in it*, Cusp Books, 2007.

"Knowledge of Freedom" in *CR: The New Centennial Review* 4:2, Fall 2004, 269–310.

*In the Break: The Aesthetics of the Black Radical Tradition*, University of Minnesota Press, 2003.

*Poems* (with Jim Behrle), Pressed Wafer, 2002.

*Arkansas*, Pressed Wafer, 2000.

## Selected Solo Exhibitions

**2015**
Wu Tsang, ICA, London, UK (Upcoming)

**2014**
Wu Tsang, Migros Museum, Zurich, Switzerland, travels to Düsseldorf February 2015
*Body Doubles*, MCA Chicago, Chicago
*A day in the life of bliss*, Galerie Isabella Bortolozzi, Berlin, Germany
*Moved by the Motion*, Diverse Works, Houston

**2011**
*Re:New/Re:Play Residency and Public Program*, New Museum, New York
Wu Tsang, Clifton Benevento, New York

## Selected Screenings

**2014**
*Wildness*, MACBA, Barcelona, Spain
*Wildness*, Guggenheim Museum, New York

**2013**
*WILDNESS*, Nottingham Contemporary, Nottingham, UK
*Tied and True as part of Future Perfect: States of Time*, Tate Modern, London
*WILDNESS and State of a Right Statement*, Stedelijk Museum, Amsterdam
*Kinoapparatom presents:Cinéma Oblique*, Kunsthaus Bregenz, Austria
*WILDNESS*, Palais de Tokyo, Paris, France
*WILDNESS, The Tanks at Tate Modern*, London, UK

**2012**
*The Contenders*, MoMA
*Frieze Film*, Frieze Foundation, Frieze Art Fair, London
*Documentary Fortnight*, MoMA

**2007**
*Dead, Absent, and Fictitious*, Documenta 12, Kassel, Germany

**2004**
*Elusive Quality*, Liverpool Biennial @ FACT Centre, Liverpool, UK

## Bibliography

**2014**
"Wu Tsang: Invisible Boundaries," *Art Asia Pacific*, May/June, 84–85.

**2013**
Henry, Joseph, "Jon Davies Talks His New Wu Tsang Exhibition and Queer Curation," Blouin Artinfo Canada, November 13.
Lax, Thomas J., "Feeling Conceptual," *Mousse Magazine*, April/May, 130–39.

**2012**
Thorne, Sam, "Focus: Wu Tsang," *Frieze*, Issue 145.
Wyma, Chloe ,"I Dislike the Word Visibility': Wu Tsang on Sexuality, Creativity, and Conquering New York's Museums," Artinfo, March 2.

**2011**
"Preview: Wu Tsang," *Mousse Magazine*, Summer Issue.
Barliant, Claire, "Wu Tsang," *New Yorker*, July 11.
Cornell, Lauren, "Two Questions for Wu Tsang," *Rhizome*, June 22.
Cotter, Holland, "Wu Tsang," *New York Times*, July 8, 27.
Fitzpatrick, Corrine, "Critics Pick," Artforum.com, June.
McGarry, Kevin, "Wu Tsang: body quotations, back-breaking sparkle and the dissemination of wildness," *Mousse Magazine*, Issue 30, October/ November, 127–29.
Schneider, Anja Isabel, "Wu Tsang," *Kaleidoscope*, Issue 12, Fall, 102.

**2008**
Bordowitz, Gregg, PSi #14: Interregnum: In-Between States, "Sentiment, Belief, and Medium," Film, Avant-Garde and Biopolitics.

**2006**
Wolf, Matt, "New Live Queer Art," *The Uncertain States of America Reader*, Sternberg Press.

Bibliography

Bel, Jérome, Charmatz Boris, *Emails 2009–2010*, Les Presses du Réel.

Bembekoff, Marc, *Nouvelles Vagues* in Magazine Palais n°18, Palais de Tokyo, Paris.

Bleeker, Maaike, De Belder Steven, Debo Kaat, Van den Dries Luk, Vanhoutte Kurt, *Bodycheck: Relocating the Body in Contemporary Performing Art* in Critical studies n°17, Rodopi.

Carter, Alexandra, *Rethinking dance history*, a reader, Routledge.

Copeland, Mathieu, *Choreographing Exhibitions / Chorégraphier l'exposition*, Les Presses du Réel.

Etchells, Tim, *Certain Fragments*, Routledge.

Goldberg, Roselee, *Performance Art: From Futurism to the present*, World of Art, Thames and Hudson.

Goldberg, Roselee, *Performances, l'art en action*, Thames and Hudson, New-York, London.

Heathfield, Adrian, *Live Art and Performance*, Tate London.

Hoffmann, Jens, *Action*, Thames and Hudson.

Lepecki, Andre, *Exhausting dance, performance and the politics of movement*, Routledge, New-York, London.

Pontbriand, Chantal, *Dance: distinct language and cross-cultural influences*, Parachute, Montreal.

Siegmund, Gerald, *Abwesesenheit. Eine performative ästhetik des Tanzes. Wiliam Forsythe, Jerome Bel, Xavier Le Roy, Meg Stuart*, Transcript.

Umathum, Sandra, Wihstutz Benjamin, *Disabled Theater*, Diaphanes.

Volckers, Hortensia, *Remembering the body*, Hatje Cantz.

Von Hantelman, Dorothea, *I promise it is political*, Ludwig Museum.

# Jérôme Bel

Born 1964 in
Montpellier, France
Lives and works
in Paris

Jérôme Bel is a French dancer
and choreographer. Bel
was inspired to study dance
after witnessing *Nelken* by
Pina Bausch and *Rosas danst
Rosas* by Anne Teresa De
Keersmaeker, two significant
pieces performed at the
1983 Festival d'Avignon.
From 1984–85, he studied
choreography at the Centre
chorégraphique national
in Angers, followed by
dancing for a variety of
choreographers from
1985–91, including Angelin
Preljocaj, Régis Obadia,
Daniel Larrieu, and Caterina
Sagna. At the forefront of
European conceptual dance,
Bel's choreographic projects
are driven by poststructuralist
theory, and his self-referential
work reflects upon the
theoretical aspects of
performance, pioneering the
choreographic style of non-
dance. His work addresses
issues of representation,
rejects expectations of dance
as cohesive entertainment,
and toggles assumptions
about authorship, choosing
the deconstruction of
conventional composition
as a major theme in his
performances. Bel received
a Bessie Award for the
performances of *The show
must go on* in New York in
2005. In 2008 Bel and Pichet
Klunchun received the Routes
Princess Margriet Award for
Cultural Diversity (European
Cultural Foundation) for *Pichet
Klunchun and myself* (2005),
and in 2013 *Disabled Theater*
(2012) was selected for the
Theatertreffen in Berlin and
won the Swiss Dance Awards -
Current Dance Works.

## Choreographic Works

| | |
|---|---|
| 2013 | Cour d'Honneur |
| 2012 | *Disabled Theater* |
| 2010 | *3Abschied* |
| 2009 | *Cédric Andrieux* |
| 2005 | *Pichet Klunchun and Myself* |
| 2005 | *Isabel Torres* |
| 2004 | *Véronique Doisneau* |
| 2001 | *The Show Must Go On* |
| 2000 | *Xavier Le Roy* |
| 1998 | *Le Dernier Spectacle* |
| 1997 | *Shirtologie* |
| 1995 | *Jérôme Bel* |
| 1994 | *Nom donné par l'auteur* |

**2010**
Voice and Wind, New Museum, New York
Voice over Three, Artsonje Center, Seoul, South Korea Closures, Galerie Wien Lukatsch, Berlin, Germany

**2009**
Integrity of the Insider, Walker Art Center, Minneapolis
Condensation, South Korean Pavilion, 53rd Venice Biennale, Venice, Italy

**2008**
Symmetric Inequality, Sala Rekalde, Bilbao, Spain
Asymmetric Equality, Redcat, Los Angeles
Siblings and Twins, Portikus, Frankfurt am Main, Germany
Lethal Love, Cubitt Gallery, London, UK

**2006**
Sadong 30, Incheon, South Korea
Unevenly, BAK, basis voor actuele kunst, Utrecht, The Netherlands

**2008**
If we can't get it together, The Power Plant, Toronto, Canada
Farewell to Post-Colonialism, The 3rd Guangzhou Triennial, Guangzhou, Guangdong, China
Life On Mars, 55th Carnegie International, Pittsburgh
Wessen Geschichte, Kunstverein Hamburg, Hamburg, Germany

**2007**
If I can't dance, I don't want to be part of your Revolution. Episode IV: Feminist Legacies and Potentials in Contemporary Practice, Museum van Hedendaagse Kunst Antwerpen (MuHKA), Belgium
Brave New Worlds, Walker Art Center, Minneapolis; La Coleccion Jumex, Mexico City, Mexico
Imagine Action, Lisson Gallery, London, UK

**2006**
If I can't dance, I don't want to be part of your Revolution, Episode II: Feminist Legacies and Potentials in Contemporary Practice, de Appel, Amsterdam, The Netherlands
Como Viver Junto (How to Live Together), 27th São Paulo Biennale, São Paulo, Brazil

**2003**
Demirrorized Zone, de Appel, Amsterdam, The Netherlands

**2002**
Manifesta 4, European Biennial of Contemporary Art, Frankfurt am Main, Germany
Ssamzie Studio 3, Ssamzie Space, Seoul, South Korea

**2000**
Art or Design, Seoul Arts Center, Seoul, South Korea

**2011**
Haegue Yang: Wild Against Gravity, ed. by Ryan Shafer and Emily Smith, exh. cat. Aspen Art Museum, Colorado & Modern Art Oxford, Oxford, UK, 2011.
Haegue Yang: Arrivals, Catalogue raisonné 1994–2011, ed. by Yilmaz Dziewior, exh. cat. Kunsthaus Bregenz, Berlin, 2011.

**2010**
Haegue Yang: Siblings and Twins, ed. by Melanie Ohnemus, exh. cat. Portikus, Frankfurt am Main 2010.

**2009**
Haegue Yang: Condensation, ed. by Eungie Joo, exh. cat. Arts Council Korea, Seoul/Berlin 2009.

**2008**
Haegue Yang: Asymmetric Equality, ed. by Clara Kim, exh. cat. REDCAT, Sala Rekalde, Los Angeles, Bilbao 2008.

**2007**
Haegue Yang: Community of Absence, ed. by Binna Choi, exh. cat. BAK, basis voor actuele kunst, Utrecht /Frankfurt am Main 2007.
Haegue Yang: Sadong 30, ed. by Hyunjin Kim, exh. cat. Sadong 30, Berlin 2007.

## Haegue Yang

Born 1971 in Seoul, South Korea
Lives and works in Berlin and Seoul

Haegue Yang's work is known for its eloquent language of visual abstraction combining direct sensory manipulation. Bringing together a variety of working methods—ranging from complex installations with industrially produced items to hand-made sculptures using quasi-traditional crafts, like knitting, paper-making, origami, and macramé—Yang is in constant search of new materials, methodologies, and ways of spatial and plastic articulation. Industrially manufactured items unfold in non-conventional arrangements as Yang translates her ongoing research on specific historical figures and their concrete domestic environments into a meticulous language of formalistic abstraction, narrating invisible politics through new methods of perception. In her work, Yang uses quotidian objects and materials—including laundry racks, decorate lights, infrared heaters, Venetian blinds, scent emitters, and industrial fans—to create visually abstract sculptures.

### Selected Solo Exhibitions

**2015**
Shooting the Elephant 象
Thinking the Elephant, Leeum,
Samsung Museum of Art, Seoul,
South Korea

**2014**
Follies, manifold: Gabriel Lester –
Haegue Yang, Bonner Kunstverein,
Bonn, Germany

**2013**
Anachronistic Layers of Dispersion,
Henry Art Gallery, Seattle
Journal of Echomimetic Motions,
Bergen Kunsthall, Bergen, Norway
Family of Equivocations, Aubette
1928 and Museum of Modern and
Contemporary Art, Strasbourg,
France
Ovals and Circles, Galerie Chantal
Crousel, Paris, France
Art Wall: Haegue Yang, ICA, Boston

**2012**
Der Öffentlichkeit – von den
Freunden Haus der Kunst,
Haus der Kunst, Munich,
Germany
The Tanks: Art in Action, Tate Modern,
London, UK
Multi Faith Room, Greene Naftali,
New York

**2011**
The Art and Technique of Folding
the Land, Aspen Art Museum, Aspen,
Colorado
Arrivals, Kunsthaus Bregenz,
Bregenz, Austria

### Selected Group Exhibitions

**2014**
The Great Acceleration, Taipei
Biennial 2014, Taipei, Taiwan
Ghosts, Spies and Grandmothers,
SeMA Biennale Mediacity Seoul
2014, Seoul, South Korea

**2012**
The Living Years: Art after 1989,
Walker Art Center, Minneapolis
dOCUMENTA (13), Kassel, Germany
Abstract Possible: The Stockholm
Synergies, Tensta Konsthall,
Stockholm, Sweden

**2011**
Open Days, Le Consortium, Dijon,
France
Human Nature: Contemporary Art
from the Collection, LACMA –
Los Angeles County Museum of Art,
Los Angeles

**2009**
Your Bright Future: 12 Contemporary
Artists from Korea, LACMA – Los
Angeles County Museum of Art,
Los Angeles (traveled to the Museum
of Fine Arts, Houston)

### Bibliography

**2013**
Bathroom Contemplation. How
to write 4, by Haegue Yang, Wien
Lukatsch Berlin, Germany, 2013.
Haegue Yang: Der Öffentlichkeit – von
den Freunden Haus der Kunst, ed.
by Julienne Lorz, exh. cat. Haus der
Kunst, Munich, 2013.
Haegue Yang: Dare to Count
Phonemes and Graphemes, ed.
by Kyla McDonald and Steinar
Sekkingstad, exh. cat. Bergen
Kunsthall and Glasgow Sculpture
Studios, 2013.
Haegue Yang: Family of
Equivocations, ed. by Camille
Giertler and Lize Braat, exh. cat.
l'Aubette and Musée d'Art Moderne
et Contemporain de Strasbourg,
Strasbourg, France, 2013.

## Litia Perta

Litia Perta is a Professor of Art at the University of California Irvine where she teaches Art Writing and Critical & Curatorial Studies. She received her PhD from the Department of Rhetoric at the University of California Berkeley in 2007 and was a Mellon postdoctoral fellow at Wesleyan University until 2009. She has taught critical theory in the art departments at Parsons The New School for Design and The Cooper Union and was a faculty member of Bard College's Language & Thinking program. Through lyrical non-fiction, critical theory, and performance, her research mobilizes an interdisciplinary examination of the ways in which non-normative subjectivities, particularly those that have been historically marginalized, come to personhood through art. Perta's recent work has been included in the publications *Anyone Telling Anything is Telling that Thing* by Eve Fowler (Printed Matter, 2013) and *Dear Nemesis: Nicole Eisenman 1993–2013* (Contemporary Art Museum St. Louis, 2014). Her essays have also been published by *Randy Magazine*, Night Gallery's *Night Papers*, *Capricious Magazine*, and *The Brooklyn Rail*.

Published on the occasion of the exhibition *Double Life*, organized by Dean Daderko, Curator, for the Contemporary Arts Museum Houston

December 13, 2014 – March 15, 2015

*Double Life* is supported in part by Glen Gonzalez and Steve Summers.

The catalogue accompanying the exhibition is made possible by a grant from The Brown Foundation, Inc.

Jérôme Bel's installation and performance is supported by the Cullen Trust for the Performing Arts; and funded in part by FUSED: French U.S. Exchange in Dance, a program of the New England Foundation for the Arts' National Dance Project, the Cultural Services of the French Embassy in the United States, and FACE (French American Cultural Exchange), with funding from the Doris Duke Charitable Foundation, The Andrew W. Mellon Foundation, and the Florence Gould Foundation.

This exhibition has been made possible by the patrons, benefactors and donors to the Museum's Friends of Steel Exhibitions:

Director's Circle
Chinhui Juhn and Eddie Allen
Fayez Sarofim
Michael Zilkha

Curator's Circle
Marita and J.B. Fairbanks
Dillon Kyle Architecture, Inc.
Mr. and Mrs. I. H. Kempner III
Ms. Louisa Stude Sarofim

Major Exhibition Circle
A Fare Extraordinaire
Bank of Texas
Bergner and Johnson Design
Jereann Chaney
Elizabeth Howard Crowell
Sara Paschall Dodd
Ruth Dreessen and Thomas Van Laan
Jo and Jim Furr
Barbara and Michael Gamson
Brenda and William Goldberg
Blakely and Trey Griggs
George and Mary Josephine Hamman Foundation
Jackson and Company
Louise D. Jamail
Anne and David Kirkland
KPMG, LLP
Beverly and Howard Robinson
Lauren Rottet
Robin and Andrew Schirrmeister
Leigh and Reggie Smith
Yellow Cab Houston

Funding for the Museum's operations through the Fund for the Future is made possible by generous grants from Chinhui Juhn and Eddie Allen, Anonymous, Jereann Chaney, Marita and J.B. Fairbanks, Jo and Jim Furr, Barbara and Michael Gamson, Brenda and William Goldberg, Leticia Loya, Fayez Sarofim, Robin and Andrew Schirrmeister and David and Marion Young.

The Museum's operations and programs are made possible through the generosity of the Museum's trustees, patrons, members and donors. The Contemporary Arts Museum Houston receives partial operating support from The Brown Foundation, Inc., Houston Endowment, the City of Houston through the Houston Museum District Association, the National Endowment for the Arts, the Texas Commission on the Arts, The Wortham Foundation, Inc. and artMRKT Productions. CAMH also thanks its artist benefactors for their support including Jules de Balincourt, Jack Early, Mark Flood, Keltie Ferris, Barnaby Furnas, Theaster Gates, Trenton Doyle Hancock, Mary Heilmann, Jim Hodges, Jennie C. Jones, Klara Lidén, Maya Lin, Robert Mangold, Melissa Miller, Marilyn Minter, Angel Otero, Enoc Perez, Rob Pruitt, Matthew Ritchie, Dario Robleto, Ed Ruscha, Rusty Scruby, Cindy Sherman, Lorna Simpson, James Surls, Sam Taylor-Johnson, and William Wegman.

Official Airline of the Contemporary Arts Museum Houston

Unless otherwise noted, all photographs
by Paul Hester
© Contemporary Arts Museum Houston

Page 62:
*Cédric Andrieux*, 2009
Performance still
© Marco Caselli Nirmal

Page 67:
Photographs of Helen Foster Snow
and Jang Jirak from the Helen Foster Snow
Papers, L. Tom Perry Special Collections,
Harold B. Lee Library,
Brigham Young University, Provo, UT

Pages 88, 90–91:
Wu Tsang
*Full Body Quotation*, 2011
Performance still
Presented by the New Museum
for *Performa 11*
Courtesy the artist and
Clifton Benevento, New York

Page 100:
Haegue Yang
*Mountains of Encounter*, 2008
Aluminum Venetian blinds,
powder-coated aluminum hanging
structure, steel wire, moving
spotlights, floodlights, platform
ladder, and cable
Dimensions variable
Courtesy Galerie Wien Lukatsch, Berlin
and Greene Naftali, New York
Installation view from *Wessen Geschichte*
[Whose (His)Story], Kunstverein in
Hamburg, Germany, 2008
Photo: Fred Dott, Hamburg

Pages 160–161:
© Wu Tsang and Fred Moten

Published by
Contemporary Arts Museum Houston
5216 Montrose Boulevard
Houston, Texas 77006
www.camh.org

Distributed by
D.A.P. / Distributed Art Publishers
155 Sixth Avenue
New York NY 10013
www.artbook.com

Library of Congress Control Number
2014960367

ISBN: 978-1-933619-53-8

Design:
AHL&CO / Peter Ahlberg, Michael Wong

Editing:
AHL&CO / Joanna Ahlberg

Printing:
Shapco Printing, Minneapolis, MN

Binding:
Midwest Editions, Minneapolis, MN

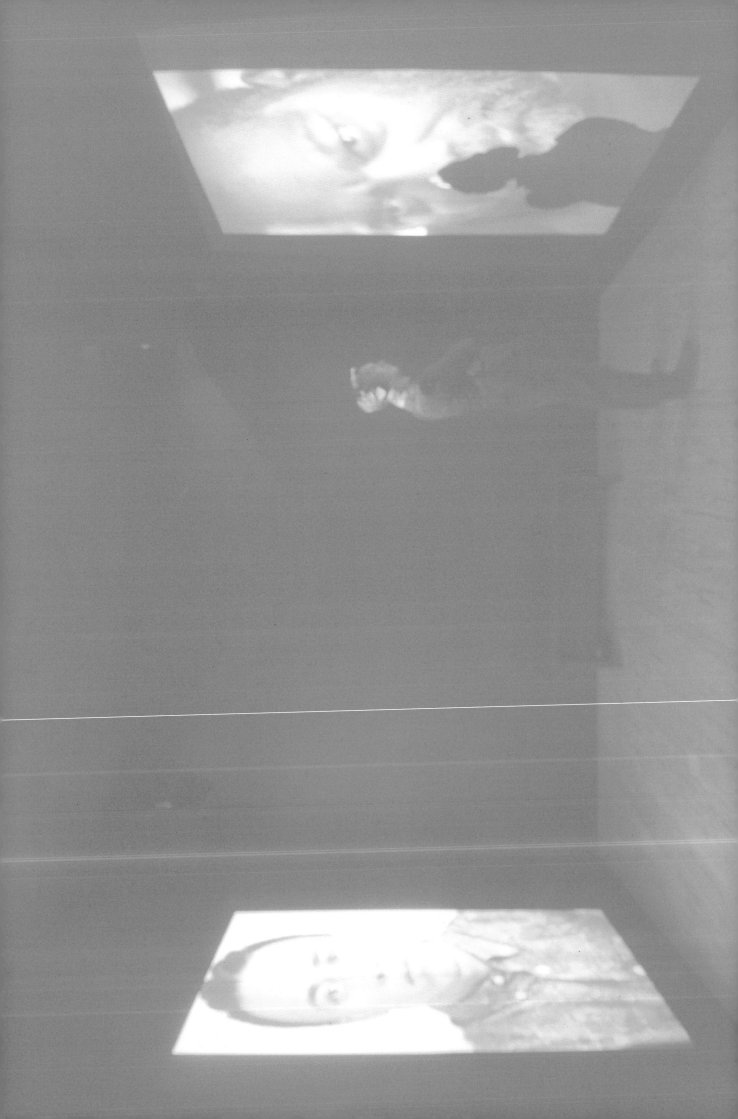

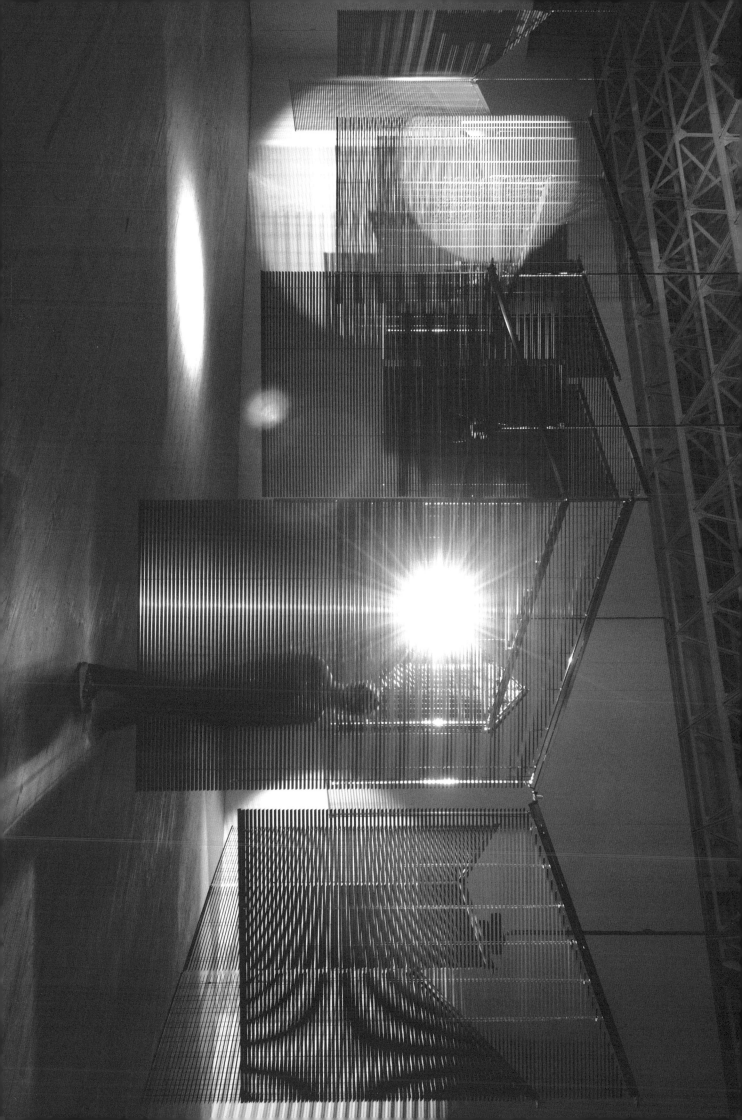